# CANYONS OF THE COLORADO

For Lena

Joseph Holm

7-28-04

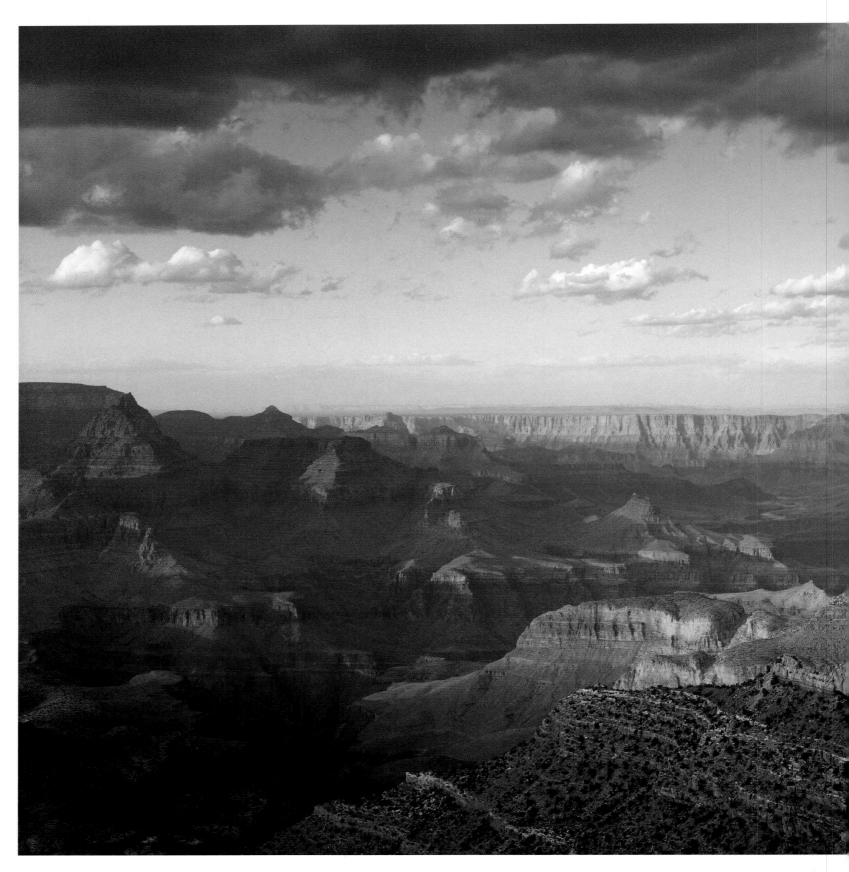

# HE COLORADO

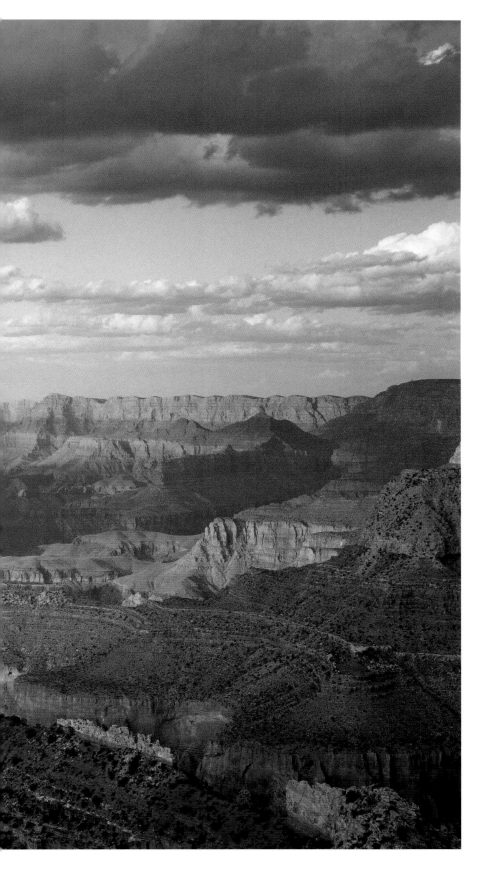

Photographs and Essays by

## Joseph Holmes

Foreword by

## David R. Brower

Text Excerpted from
*The Exploration of the Colorado River and Its Canyons* by

## John Wesley Powell

**CHRONICLE BOOKS**
SAN FRANCISCO

To my daughters Courtney and Jessica and the beauty they may find.

*Editor's Note:* Although John Wesley Powell professed his interest in the
Colorado Basin to be of a purely scientific nature, it is impossible to
read his journal and not be struck by both his zest for adventure and
wonder at the splendid sights he beheld. The version reprinted here is
edited from the original, and I urge interested readers to seek out the
complete text, which is available in several excellent editions.—C.K.

A catalogue record is available from the Library of Congress.

ISBN 0-8118-1417-3  pb
ISBN 0-8118-1566-8  hc

Printed in Singapore

Distributed in Canada by
Raincoast Books
8680 Cambie St.
Vancouver, B.C.
V6P 6M9

1 2 3 4 5 6 7 8 9 10

Chronicle Books
275 Fifth Street
San Francisco, CA 94103

# CONTENTS

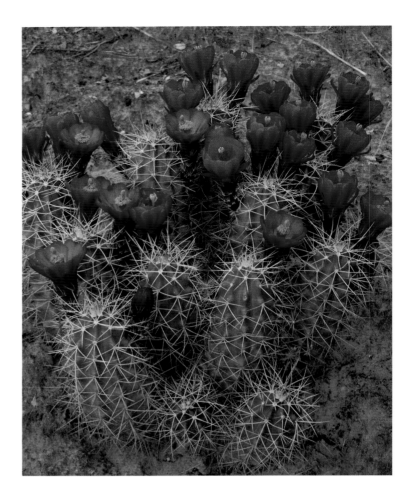

# LEST WE FORGET
## THE COLORADO PLATEAU

*Finer forms are in the quarry*
*Than ever Angelo evoked.*

Long before Alexander Pope wrote these lines, still longer before Michelangelo evoked his David, and eons before our species appeared on Earth, the Colorado River was waiting for its quarry to show up. The Grand Canyon and its tributary canyons would not have been conceived of yet, nor any of the other familiar forms the Colorado River has thought it worthwhile to liberate. The river hadn't even heard of the poet, Li Po.

Li Po, who died in A.D. 762, knew that he and Ching-Ting, a favorite mountain of his, would never grow tired of each other. That is a nice kind of relationship to have with a mountain. Joseph Holmes has one like it with the Colorado River country. So did Eliot Porter, Wallace Stegner, and John Wesley Powell. Wallace Stegner's book of 1954, *Beyond the Hundredth Meridian,* superbly describes Powell's Colorado River adventure and the rest of his history-making career. Eliot Porter's book, *The Place No One Knew*, informed Joseph Holmes's sensitivity to image, color, word, and place. When Father Thomas Berry urged that we put the Bible on the shelf for a while and read the Earth, Joe had already found some of the best places on Earth to start reading.

Quite a few of those places were celebrated in the calendars Joe created for Friends of the Earth. These calendars helped to increase people's awareness about and appreciation of these places, as for example, in the preservation of Mono Lake. The waters of the lake were coveted by Los Angeles, but visitors to Yosemite's east side admired its desert grandeur so much they outcoveted Los Angeles. Another calendar, which eventually led to this book, revealed the beauty of one of the Colorado River's tributaries, the Escalante.

Joe did much more than provide photographs for these calendars: he also found co-publishers, selected text, and de-

signed them. He produced the mechanicals so he could see that his design remained intact. He made sure that the printer in Verona stayed true to the concept by delegating someone to watch the press run. I volunteered. He once told me that I was watching over his shoulder in spirit when he made his photographs. If this tribute is justified, it must be attributed entirely to my years of work with Ansel Adams, Cedric Wright, Philip Hyde, Eliot Porter, and let's add Joe himself—to mention my most illustrious coaches.

Let me now reveal our hidden agenda here. We want to enlist your help in restoring the most beautiful place in all the world. I am qualified to designate such a place because an eminent authority on John Muir wrote that I am the John Muir reincarnate. Moreover, another eminent authority has revealed that I am an Archdruid (not knowing that there really is one). I can assure you that Muir and the Archdruid agree about Glen Canyon.

John Wesley Powell dearly loved the place and named it for its many verdant glens. A tachometer would surely have spun over his grave the day the United States Bureau of Reclamation played Satan and named the reservoir that destroyed the canyon "Lake Powell." As a reservoir, not a lake, it has already inundated 186 miles of the Colorado River, along with uncounted miles of exquisite side canyons and some eighty miles of Glen Canyon's major tributary, the San Juan River. That was bad

news enough. Unless Glen Canyon dam is removed, on purpose or by accident, its reservoir will eventually fill with sediment—rock, boulders, sand, and silt. The sediment will pile up ninety feet higher than the water itself at the reservoir's present head. Another foot or so of sediment per mile of river will accumulate upstream and be that much higher still. All in all, the news is bad, messy, and will cost the future far more than dam builders want you to know. It also means that the hydroelectric power generated with reservoirs is not a renewable resource. You can't run a generator on sediment. They don't want you to know that either. And an unindentured expert is hard to find.

In 1956 neither Congress nor President Eisenhower knew what was at stake at Glen Canyon, nor for that matter, did the Sierra Club. I was its executive director then and I knew, but I was not permitted to do what I could have done to help block the Colorado River Storage Project until such time as it made sense. I failed to insist that I be given permission. Of my several failures, this is the finest of all so far.

So in 1956, the construction of Glen Canyon dam began with a blast. The dam violated not only one of the most magnificent gestures of the Earth, but also the Colorado River Interbasin Compact. In the years since 1963, when the inundation began, this great mistake has literally blown away, through useless evaporation from the reservoir, two years' average flow of the entire Colorado River.

Yes, the reservoir does make sure that water will flow downhill, in a regulated manner. But it also severely diminishes the quality of water that Arizona, California, and Nevada get, and doesn't deliver Mexico's share of the Colorado over the border in a condition fit for mixing with bourbon, as Congressman Clair Engle pointed out in one of the many Congressional hearings I testified at. It did all this to put hundreds of man-years of labor where it wasn't needed and millions of kilowatt-hours in Phoenix and Las Vegas that could have been, and still can be, put there less expensively, and, to put it calmly, without such an irresponsibly profligate, recklessly unconscionable waste of irreplaceable water.

So having learned what is at stake, will you please help solve the problem by letting the Colorado River run *through* Glen Canyon dam? Let the dam stand as a monument to blind progress until that kind of progress is needed again, if it ever is. But how can we bring this new meaning to "The River Runs Through It"? Well, in order to build the dam in the first place, they had to bypass the river. So just reopen the bypass (not exactly a simple procedure) and enlarge it enough (perhaps with a double bypass; surgeons are good at it) to accommodate the river in full flood. The Grand Canyon and all its magic will be grateful for that.

Just remember the essentials about Glen Canyon dam. It illegally violated an Interstate Compact that should take pre-cedence over laws enacted by Congress. It wastes water by unnecessarily evaporating enough of it to supply two cities the size of Denver—and there is none to waste. There are far less wasteful sources of power than that produced at the expense of Glen Canyon. The wasted Colorado River watershed can be healed with a long overdue effort. Flushing far less soil downriver will keep Lake Mead alive longer, as well as the places that rely on the water supply the river provides: Wyoming, Colorado, Utah, Arizona, New Mexico, Nevada, California, and Mexico. The restoration of Glen Canyon can do wonders for the people whose minds were bent out of shape by the ecological terrorism inflicted upon the Colorado River by the well-intentioned, if misguided, perpetrators. In any case, if one or two or more centuries from now Lake Mead fills with sediment and future generations want to waste the water at Glen Canyon, the dam will still be there ready to plug the river and downsize its mission.

The news that should have been good, and still can be, is that the Glen Canyon region could be the most magnificent gem of the National Park System—the Escalante National Park that Franklin Roosevelt dreamed of. It is possible if you want it to be. At the very least, we will end, for a century or two, the annual waste of 700,000 acre-feet of water. (Remember, each acre-foot would fill a football field with twelve inches of water from goal to goal, and if it were filled with Tanqueray gin, each acre-foot would be worth $22,000,000; mere water would be worth a bit less.) There will also be a great new national park, and millions of people—generation after generation—will be free to enjoy the canyon's beauty again and celebrate its recovery in perpetuity—an asset worth more than Bill Gates. As each of the native species of plants and animals returns, we can shout "Welcome home!" and throw a big party. The music of canyon wrens and rapids, not power boats or jet skis, will provide all the decibels we need.

And all of this because you learned from this book what you could do to restore the place no one knew well enough—and who knows how many future generations may know so much better.

David R. Brower
Berkeley, California
April 13, 1996

## INTRODUCTION
# SOMETHING TO KEEP

*When I dream about returning to the basin of the Colorado River, a huge, mysterious, and mystical trove tucked into a corner of North America, I feel awe and excitement tinged with anxiety. My many journeys into the basin have had their terrifying moments, mostly on rivers or around cliffs, but countless times I have experienced a river of its overwhelming beauty pouring through me.*

*This intoxication, shared by many other devotees of exceptional wild places, impels many of us to dedicate our lives, in one way or another, to the source of that experience. Engaging such extraordinary landscapes returns us to a place we long to be, near to the heart of creation itself. Looking for ways to ensure their survival becomes its own reward.*

*Traveling the basin of the Colorado can be restful or supremely arduous, depending on the particulars of the journey. Campers who venture only short distances from their cars have the chance to experience a nearly effortless look at some of what John Wesley Powell saw on his daunting journey. For those who choose to make a deeper exploration of the remaining expanses of uncorrupted canyon lands, such matters as the weather, the fit of one's boots, the weight of the food, and the seaworthiness of the boats remain as important as ever.*

*My own adventures have at times exceeded what many would willfully choose to endure, but my reward has been in the beauty found and in the photographs I have brought back. Major Powell and his crew were the first to float the river, but in this fertile realm I have often found the miracles I seek with a lens and in them the satisfaction of discovery.*

*After a lifetime of studying both photography of landscapes and the relationship of humanity to them, it has long been obvious to me that the fabric of wildness from which our world was made has become threadbare in a great many places. The unprecedented magnitude of our success as a species is progressively and rapidly overwhelming the planet.*

*Our course, toward ultimate technological power and toward the largest possible niche for humanity, brings us to collide ever more severely both with one another and with nature. Our response thus far has been to single out and deal with some of the most egregious and soluble symptoms of the underlying problem. In the long term, this approach will prove increasingly inadequate.*

*Instead, I suggest that the democratic institutions that largely define the character of our civilization embody a vigorous respect for the quality of our lives. Therein lies our hope of escape from the declining quality of our social and natural environment, and the continued impoverishment of nature. It is within our power to resolve to guarantee our freedom from the excessive presence in the world of everything that is of our own making. Such a resolution could enable our Constitution to effectively safeguard our lives, our liberty, and our pursuit of happiness for the long run. What happiness without the great beauties of nature or hospitable communities? What liberty for children growing up without wild places to be free? Our excess even raises threats to our very survival.*

*I hope this book will prove a useful reminder of our obligation to tread lightly and responsibly, now and forever, as we and our descendants come and go through the miracle of this, our ancient living planet.*

*Joseph Holmes*
*February 20, 1996*
*Kensington, California*

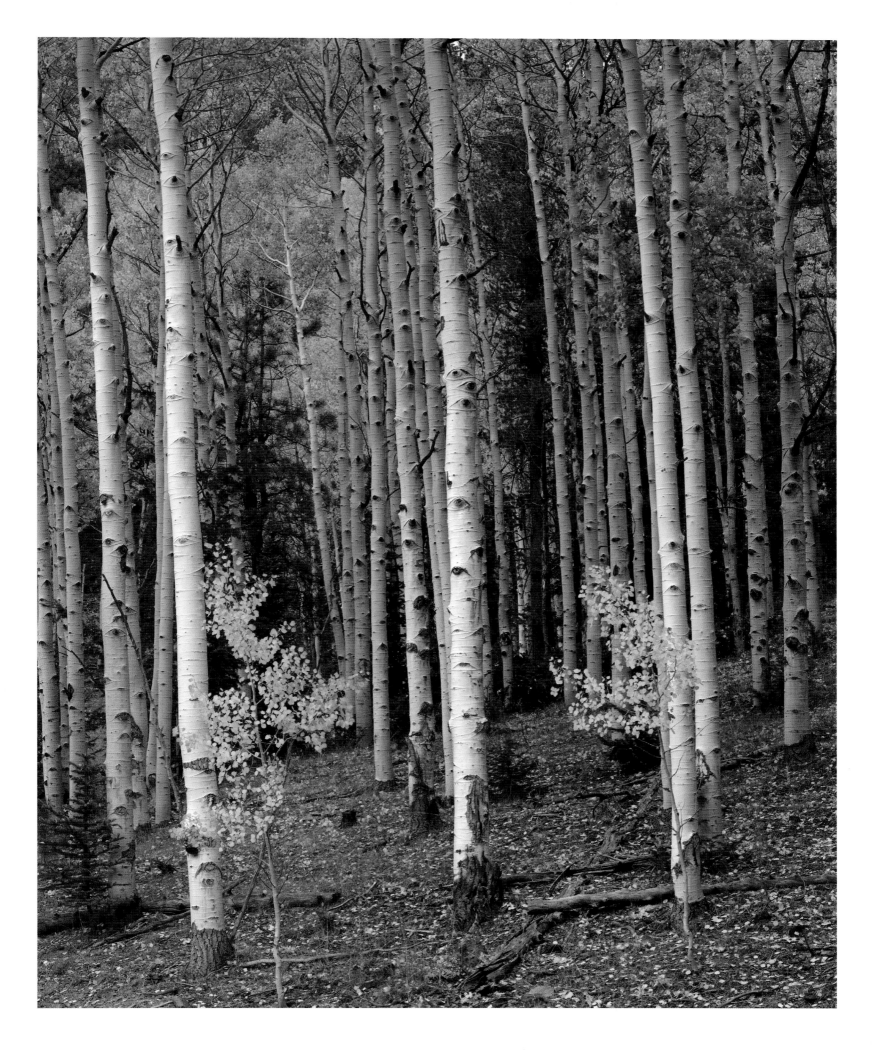

# LIST OF PLATES

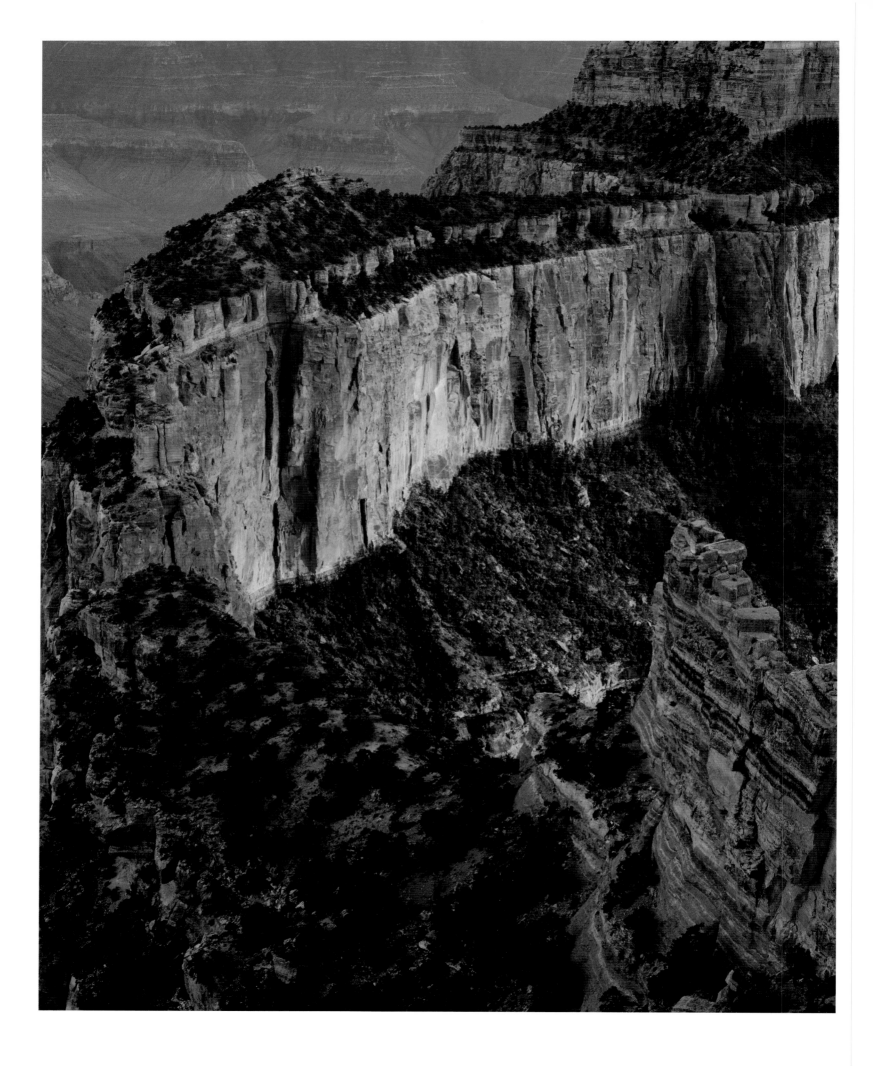

# JOHN WESLEY POWELL
# PREFACE

On my return from the first exploration of the canyons of the Colorado, I found that our journey had been the theme of much newspaper writing. A story of disaster had been circulated, with many particulars of hardship and tragedy, so that it was currently believed throughout the United States that all the members of the party were lost save one. A good friend of mine had gathered a great number of obituary notices, and it was interesting and rather flattering to me to discover the high esteem in which I had been held by the people of the United States. In my supposed death I had attained to a glory which I fear my continued life has not fully vindicated.

The exploration was not made for adventure, but purely for scientific purposes, geographic and geologic, and I had no intention of writing an account of it, but only of recording the scientific results. Immediately on my return I was interviewed a number of times, and these interviews were published in the daily press; and here I supposed all interest in the exploration ended. But in 1874 the editors of Scribner's Monthly requested me to publish a popular account of the Colorado exploration in that journal. To this I acceded and prepared four short articles, which were elaborately illustrated from photographs in my possession. . . .

My daily journal had been kept on long and narrow strips of brown paper, which were gathered into little volumes that were bound in sole leather in camp as they were completed. After some deliberation I decided to publish this journal, with only such emendations and corrections as its hasty writing in camp necessitated. It chanced that the journal was written in the present tense, so that the first account of my trip appeared in that tense. The journal thus published was not a lengthy paper, constituting but a part of a report entitled "Exploration of the Colorado River of the West and its Tributaries. Explored in 1869, 1870, 1871, and 1872, under the direction of the Secretary of the Smithsonian Institution." The other papers published

with it relate to the geography, geology, and natural history of the country. And here again I supposed all account of the exploration ended. But from that time until the present I have received many letters urging that a popular account of the exploration and a description of that wonderful land should be published by me. This call has been voiced occasionally in the daily press and sometimes in the magazines, until at last I have concluded to publish a fuller account in popular form. In doing this I have revised and enlarged the original journal of exploration, and have added several new chapters descriptive of the region and of the people who inhabit it. . . .

Many years have passed since the exploration, and those who were boys with me in the enterprise are—ah, most of them are dead, and the living are gray with age. Their bronzed, hardy, brave faces come before me as they appeared in the vigor of life; their lithe but powerful forms seem to move around me; and the memory of the men and their heroic deeds, the men and their generous acts, overwhelms me with a joy that seems almost a grief, for it starts a fountain of tears. I was a maimed man; my right arm was gone; and these brave men, these good men, never forgot it. In every danger my safety was their first care, and in every waking hour some kind service was rendered me, and they transfigured my misfortune into a boon.

To you—J. C. Sumner, William H. Dunn, W. H. Powell, G. Y. Bradley, O. G. Howland, Seneca Howland, Frank Goodman, W. R. Hawkins, and Andrew Hall—my noble and generous companions, dead and alive, I dedicate this book.

# FROM GREEN RIVER CITY TO FLAMING GORGE

MAY 24    The good people of Green River City turn out to see us start. We raise our little flag, push the boats from shore, and the swift current carries us down.

Our boats are four in number. Three are built of oak; stanch and firm; double-ribbed, with double stem and stern posts, and further strengthened by bulkheads, dividing each into three compartments. Two of these, the fore and aft, are decked, forming water-tight cabins. It is expected these will buoy the boats should the waves roll over them in rough water. The fourth boat is made of pine, very light, but 16 feet in length, with a sharp cutwater, and every way built for fast rowing, and divided into compartments as the others. The little vessels are 21 feet long, and, taking out the cargoes, can be carried by four men.

We take with us rations deemed sufficient to last ten months, for we expect, when winter comes on and the river is filled with ice, to lie over at some point until spring arrives; and so we take with us abundant supplies of clothing, likewise. We have also a large quantity of ammunition and two or three dozen traps. For the purpose of building cabins, repairing boats, and meeting other exigencies, we are supplied with axes, hammers, saws, augers, and other tools, and a quantity of nails and screws. For scientific work, we have two sextants, four chronometers, a number of barometers, thermometers, compasses, and other instruments.

The flour is divided into three equal parts; the meat, and all other articles of our rations, in the same way. Each of the larger boats has an axe, hammer, saw, auger, and other tools, so that all are loaded alike. We distribute the cargoes in this way that we may not be entirely destitute of some important article should any one of the boats be lost. In the small boat we pack a part of the scientific instruments, three guns, and three small

bundles of clothing, only; and in this I proceed in advance to explore the channel.

J. C. Sumner and William H. Dunn are my boatmen in the "Emma Dean"; then follows "Kitty Clyde's Sister" manned by W. H. Powell and G. Y. Bradley; next, the "No Name," with O. G. Howland, Seneca Howland, and Frank Goodman; and last comes the "Maid of the Canyon," with W. R. Hawkins and Andrew Hall.

Sumner was a soldier during the late war, and before and since that time has been a great traveler in the wilds of the Mississippi Valley and the Rocky Mountains as an amateur hunter. He is a fair-haired, delicate-looking man, but a veteran in experience, and has performed the feat of crossing the Rocky Mountains in midwinter on snowshoes. He spent the winter of 1886–87 in Middle Park, Colorado, for the purpose of making some natural history collections for me, and succeeded in killing three grizzlies, two mountain lions, and a large number of elk, deer, sheep, wolves, beavers, and many other animals. When Bayard Taylor traveled through the parks of Colorado, Sumner was his guide, and he speaks in glowing terms of Mr. Taylor's genial qualities in camp, but he was mortally offended when the great traveler requested him to act as doorkeeper at Breck-enridge to receive the admission fee from those who attended his lectures.

Dunn was a hunter, trapper, and mule-packer in Colorado for many years. He dresses in buckskin with a dark oleaginous luster, doubtless due to the fact that he has lived on fat venison and killed many beavers since he first donned his uniform years ago. His raven hair falls down to his back, for he has a sublime contempt of shears and razors.

Captain Powell was an officer of artillery during the late war and was captured on the 22d day of July, 1864, at Atlanta and

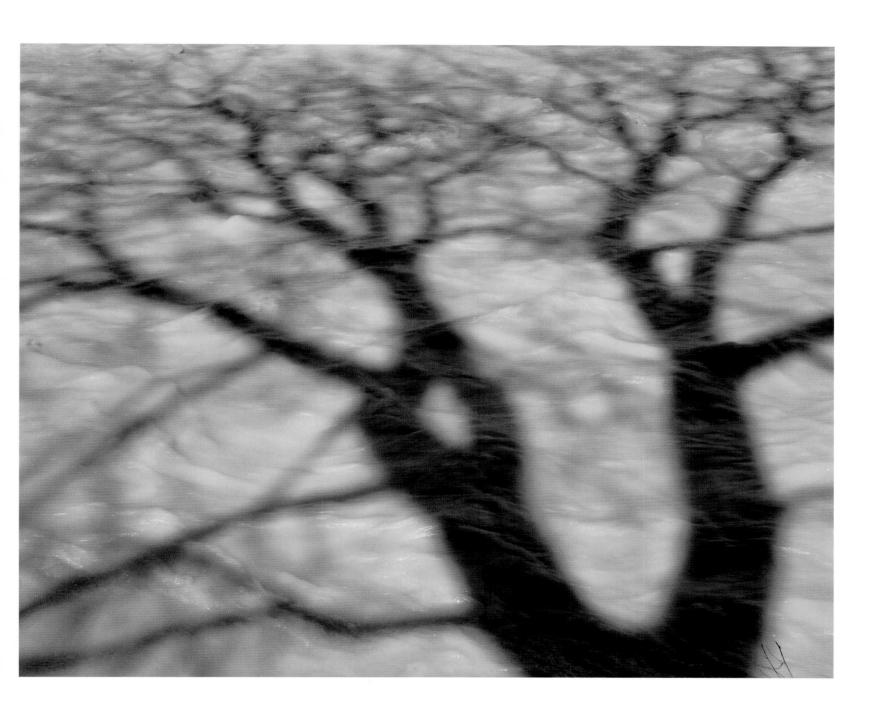

served a ten months' term in prison at Charleston, where he was placed with other officers under fire. He is silent, moody, and sarcastic, though sometimes he enlivens the camp at night with a song. He is never surprised at anything, his coolness never deserts him, and he would choke the belching throat of a volcano if he thought the spitfire meant anything but fun. We call him "Old Shady."

Bradley, a lieutenant during the late war, and since orderly sergeant in the regular army, was, a few weeks previous to our start, discharged, by order of the Secretary of War, that he might go on this trip. He is scrupulously careful, and a little mishap works him into a passion, but when labor is needed he has a ready hand and powerful arm, and in danger, rapid judgment and unerring skill. A great difficulty or peril changes the petulant spirit into a brave, generous soul.

O. G. Howland is a printer by trade, an editor by profession, and a hunter by choice. When busily employed he usually puts his hat in his pocket, and his thin hair and long beard stream in the wind, giving him a wild look, much like that of King Lear in an illustrated copy of Shakespeare which tumbles around the camp.

Seneca Howland is a quiet, pensive young man, and a great favorite with all.

Goodman is a stranger to us—a stout, willing Englishman, with florid face and more florid anticipations of a glorious trip.

Billy Hawkins, the cook, was a soldier in the Union Army during the war, and when discharged at its close went West, and since then has been engaged as teamster on the plains or hunter in the mountains. He is an athlete and a jovial good fellow, who hardly seems to know his own strength.

Hall is a Scotch boy, nineteen years old, with what seems to us a "secondhand head," which doubtless came down to him from some knight who wore it during the Border Wars. It looks a very old head indeed, with deep-set blue eyes and beaked nose. Young as he is, Hall has had experience in hunting, trapping, and fighting Indians, and he makes the most of it, for he can tell a good story, and is never encumbered by unnecessary scruples in giving to his narratives those embellishments which help to make a story complete. He is always ready for work or play and is a good hand at either.

Our boats are heavily loaded, and only with the utmost care is it possible to float in the rough river without shipping water. A mile or two below town we run on a sandbar. The men jump into the stream and thus lighten the vessels, so that they drift over, and on we go.

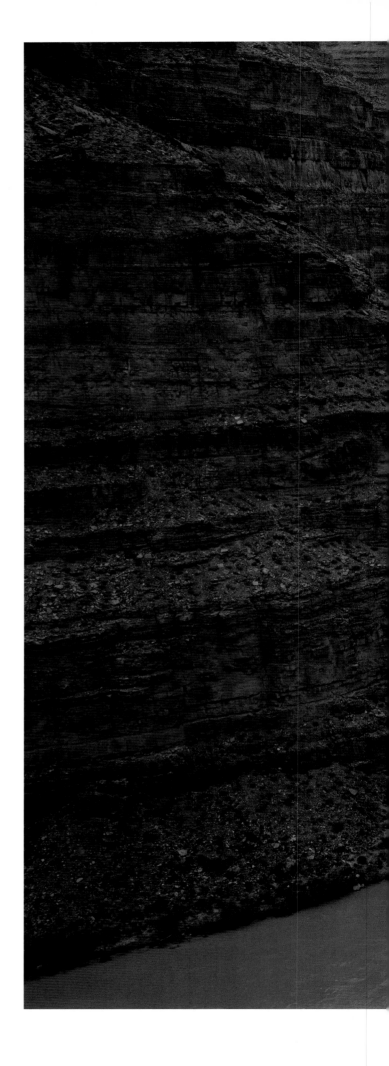

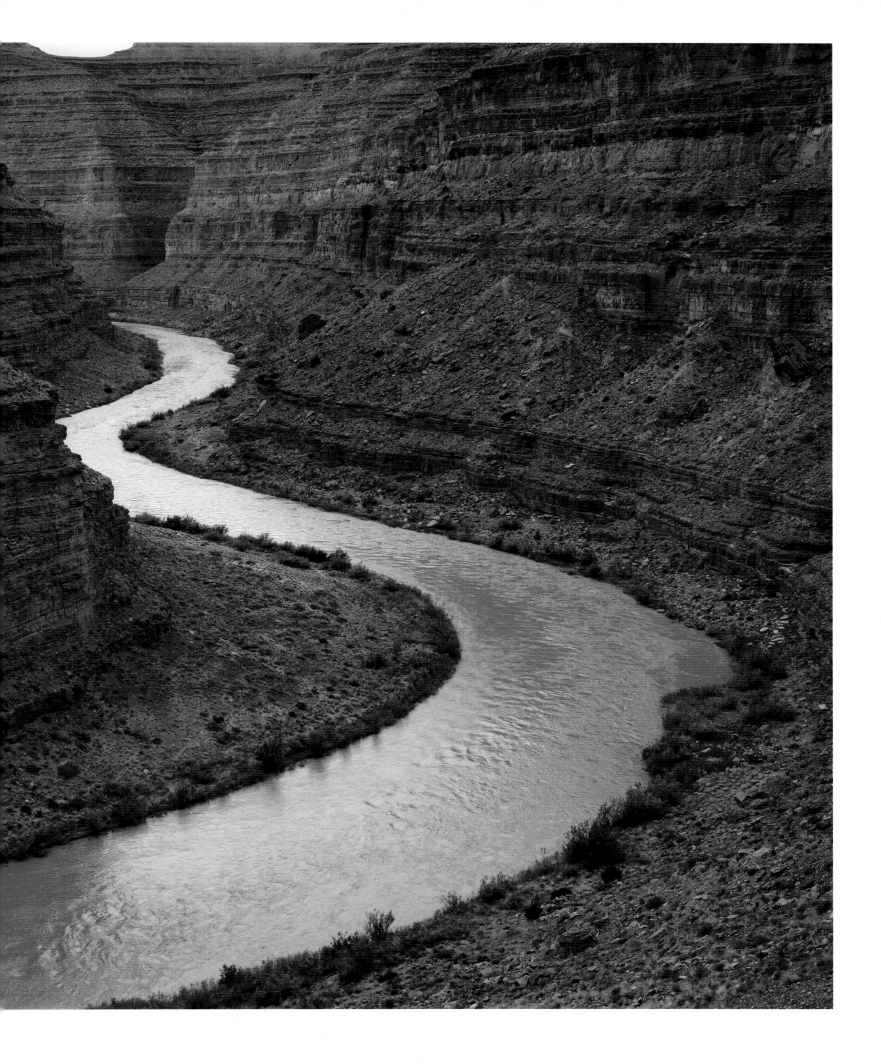

In trying to avoid a rock an oar is broken on one of the boats, and, thus crippled, she strikes. The current is swift and she is sent reeling and rocking into the eddy. In the confusion two other oars are lost overboard, and the men seem quite discomfited, much to the amusement of the other members of the party. Catching the oars and starting again, the boats are once more borne down the stream, until we land at a small cottonwood grove on the bank and camp for noon.

During the afternoon we run down to a point where the river sweeps the foot of an overhanging cliff, and here we camp for the night. The sun is yet two hours high, so I climb the cliffs and walk back among the strangely carved rocks of the Green River bad lands. . . .

Standing on a high point, I can look off in every direction over a vast landscape, with salient rocks and cliffs glittering in the evening sun. Dark shadows are settling in the valleys and gulches, and the heights are made higher and the depths deeper by the glamour and witchery of light and shade. Away to the south the Uinta Mountains stretch in a long line,—high peaks thrust into the sky, and snow fields glittering like lakes of molten silver, and pine forests in somber green, and rosy clouds playing around the borders of huge, black masses; and heights and clouds and mountains and snow fields and forests and rocklands are blended into one grand view. Now the sun goes down, and I return to camp.

MAY 25    We start early this morning and run along at a good rate until about nine o'clock, when we are brought up on a gravelly bar. All jump out and help the boats over by main strength. Then a rain comes on, and river and clouds conspire to give us a thorough drenching. Wet, chilled, and tired to exhaustion, we stop at a cottonwood grove on the bank, build a huge fire, make a cup of coffee, and are soon refreshed and quite merry. When the clouds "get out of our sunshine" we start again. A few miles farther down a flock of mountain sheep are seen on a cliff to the right. The boats are quietly tied up and three or four men go after them. In the course of two or three hours they return. The cook has been successful in bringing down a fat lamb. The unsuccessful hunters taunt him with finding it dead; but it is soon dressed, cooked, and eaten, and makes a fine four o'clock dinner.

"All aboard," and down the river for another dozen miles. On the way we pass the mouth of Black's Fork, a dirty little stream that seems somewhat swollen. Just below its mouth we land and camp.

MAY 26    To-day . . . we glide quietly down the placid stream past the carved cliffs of the *mauvaises terres,* now and then obtaining glimpses of distant mountains. Occasionally, deer are started from the glades among the willows; and several wild geese, after a chase through the water, are shot. After dinner we pass through a short and narrow canyon into a broad valley; from this, long, lateral valleys stretch back on either side as far as the eye can reach.

Two or three miles below, Henry's Fork enters from the right. We land a short distance above the junction, where a *cache* of instruments and rations was made several months ago in a cave at the foot of the cliff, a distance back from the river. Here they were safe from the elements and wild beasts, but not from man. Some anxiety is felt, as we have learned that a party of Indians have been camped near the place for several weeks. Our fears are soon allayed, for we find the *cache* undisturbed. Our chronometer wheels have not been taken for hair ornaments, our barometer tubes for beads, or the sextant thrown into the river as "bad medicine," as had been predicted. Taking up our *cache,* we pass down to the foot of the Uinta Mountains and in a cold storm go into camp.

The river is running to the south; the mountains have an easterly and westerly trend directly athwart its course, yet it glides on in a quiet way as if it thought a mountain range no formidable obstruction. It enters the range by a flaring, brilliant red gorge, that may be seen from the north a score of miles away. The great mass of the mountain ridge through which the gorge is cut is composed of bright vermilion rocks; but they are surmounted by broad bands of mottled buff and gray, and these bands come down with a gentle curve to the water's edge on the nearer slope of the mountain.

This is the head of the first of the canyons we are about to explore—an introductory one to a series made by the river through this range. We name it Flaming Gorge. The cliffs, or walls, we find on measurement to be about 1,200 feet high.

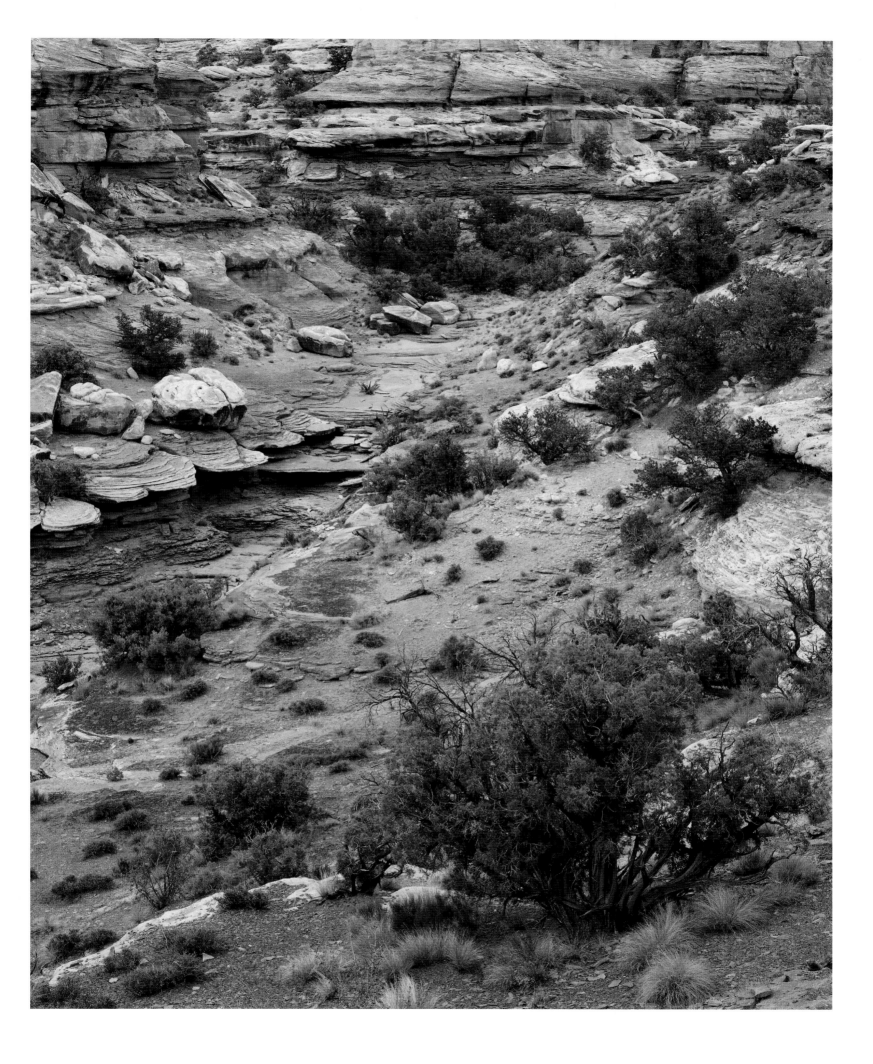

boats follow and make the landing, and we go into camp for the night.

At the foot of the cliff on this side there is a long slope covered with pines; under these we make our beds, and soon after sunset are seeking rest and sleep. The cliffs on either side are of red sandstone and stretch toward the heavens 2,500 feet. On this side the long, pine-clad slope is surmounted by perpendicular cliffs, with pines on their summits. The wall on the other side is bare rock from the water's edge up 2,000 feet, then slopes back, giving footing to pines and cedars.

As the twilight deepens, the rocks grow dark and somber; the threatening roar of the water is loud and constant, and I lie awake with thoughts of the morrow and the canyons to come. . . .

JUNE 1   To-day we have an exciting ride. The river rolls down the canyon at a wonderful rate, and, with no rocks in the way, we make almost railroad speed. Here and there the water rushes into a narrow gorge; the rocks on the side roll it into the center in great waves, and the boats go leaping and bounding over these like things of life. . . . At times the waves break and roll over the boats, which necessitates much bailing and obliges us to stop occasionally for that purpose. At one time we run twelve miles in an hour, stoppages included. . . .

At last we come to calm water, and a threatening roar is heard in the distance. Slowly approaching the point whence the sound issues, we come near to falls, and tie up just above them on the left. Here we shall be compelled to make a portage; so we unload the boats, and fasten a long line to the bow of the smaller one, and another to the stern, and moor her close to the brink of the fall. Then the bowline is taken below and made fast; the stern line is held by five or six men, and the boat let down as long as they can hold her against the rushing waters; then, letting go one end of the line, it runs through the ring; the boat leaps over the fall and is caught by the lower rope.

Now we rest for the night.

JUNE 2   This morning we make a trail among the rocks, transport the cargoes to a point below the fall, let the remaining boats over, and are ready to start before noon.

On a high rock by which the trail passes we find the inscription: "Ashley 18–5." The third figure is obscure—some of the party reading it 1835, some 1855. James Baker, an old-time mountaineer, once told me about a party of men starting down the river, and Ashley was named as one. The story runs that the boat was swamped, and some of the party drowned in one of the canyons below. The word "Ashley" is a warning to us, and we resolve on great caution. Ashley Falls is the name we give to the cataract.

The river is very narrow, the right wall vertical for 200 or 300 feet, the left towering to a great height, with a vast pile of broken rocks lying between the foot of the cliff and the water. Some of the rocks broken down from the ledge above have tumbled into the channel and caused this fall. One great cubical block, thirty or forty feet high, stands in the middle of the stream, and the waters, parting to either side, plunge down about twelve feet, and are broken again by the smaller rocks into a rapid below. Immediately below the falls the water occupies the entire channel, there being no talus at the foot of the cliffs.

We embark and run down a short distance, where we find a landing-place for dinner.

On the waves again all the afternoon. Near the lower end of this canyon, to which we have given the name of Red Canyon, is a little park, where streams come down from distant mountain summits and enter the river on either side; and here we camp for the night under two stately pines.

JUNE 3   . . . The little valleys above are beautiful parks; between the parks are stately pine forests, half hiding ledges of red sandstone. Mule deer and elk abound; grizzly bears, too, are abundant; and here wild cats, wolverines, and mountain lions are at home. The forest aisles are filled with the music of birds, and the parks are decked with flowers. Noisy brooks meander through them; ledges of moss-covered rocks are seen; and gleaming in the distance are the snow fields, and the mountain tops are away in the clouds.

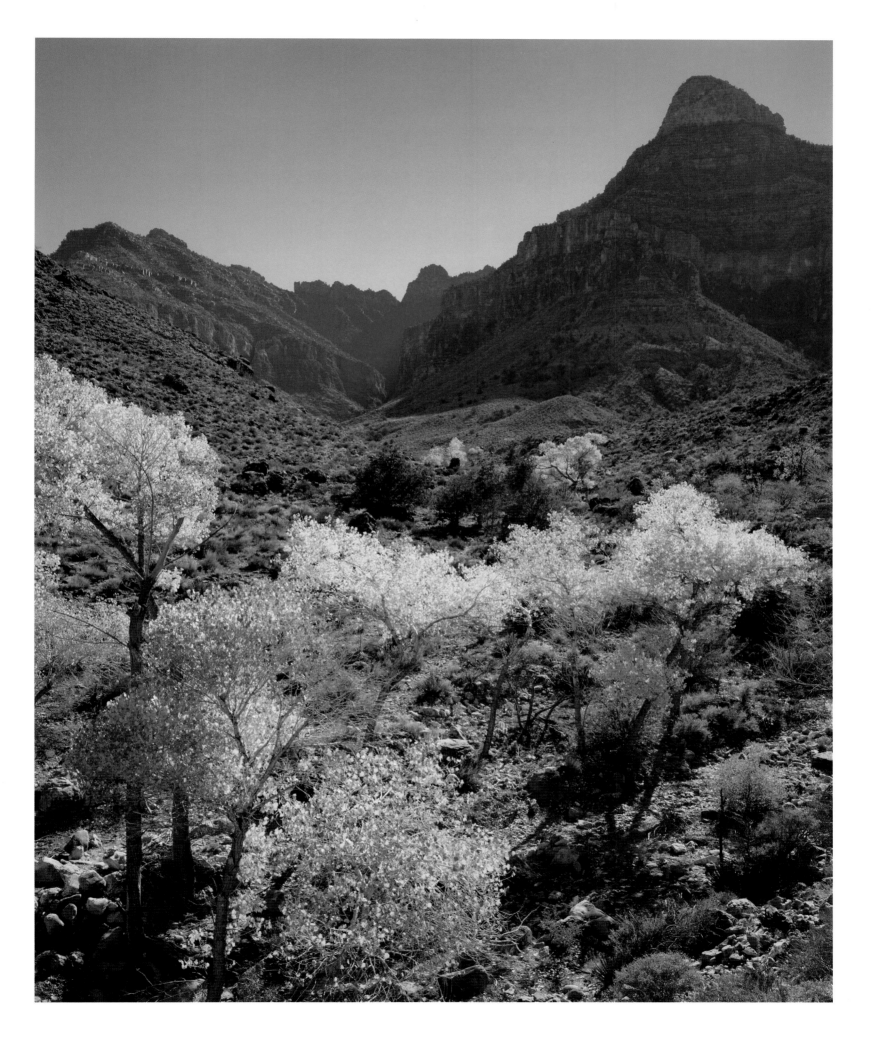

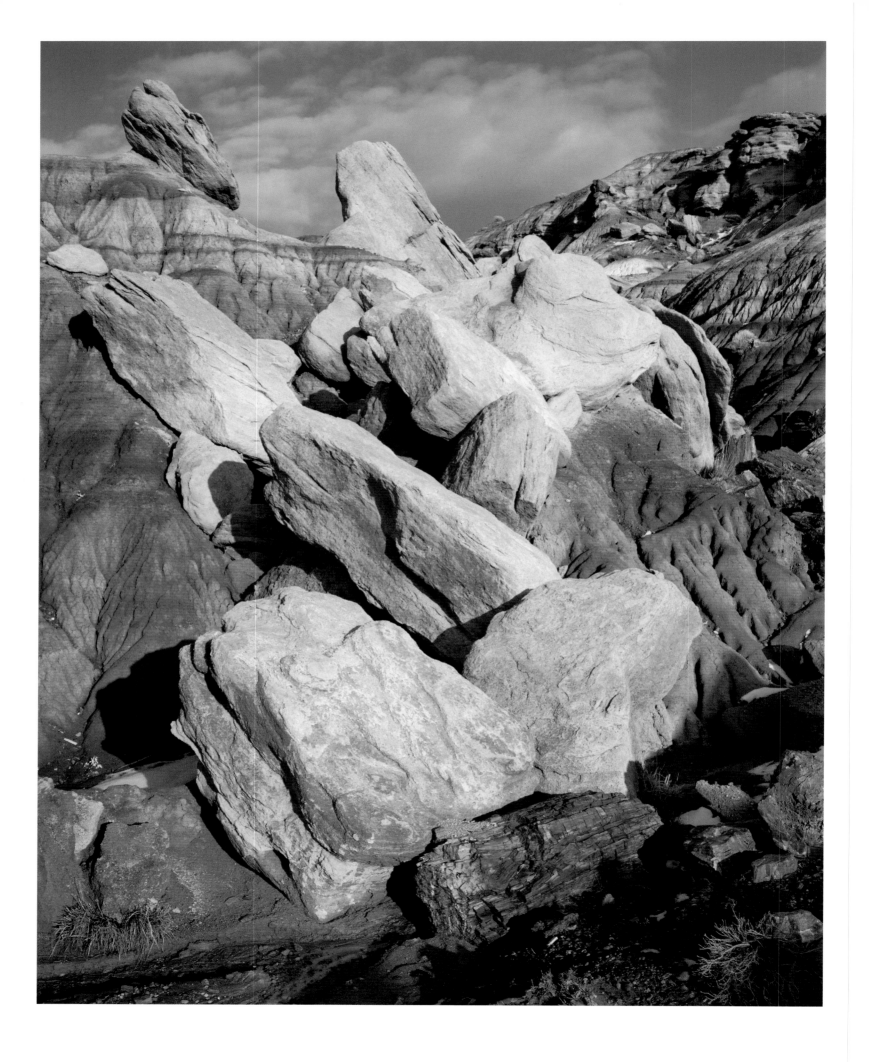

JUNE 4    We start early and run through to Brown's Park. Halfway down the valley, a spur of a red mountain stretches across the river, which cuts a canyon through it. Here the walls are comparatively low, but vertical. A vast number of swallows have built their *adobe* houses on the face of the cliffs, on either side of the river. The waters are deep and quiet, but the swallows are swift and noisy enough, sweeping by in their curved paths through the air or chattering from the rocks, while the young ones stretch their little heads on naked necks through the doorways of their mud houses and clamor for food. They are a noisy people. We call this Swallow Canyon.

Still down the river we glide until an early hour in the afternoon, when we go into camp under a giant cottonwood standing on the right bank a little way back from the stream. The party has succeeded in killing a fine lot of wild ducks, and during the afternoon a mess of fish is taken.

JUNE 6    At daybreak I am awakened by a chorus of birds. It seems as if all the feathered songsters of the region have come to the old tree. Several species of warblers, woodpeckers, and flickers above, meadow larks in the grass, and wild geese in the river. I recline on my elbow and watch a lark near by, and then awaken my bedfellow, to listen to my Jenny Lind. A real morning concert for *me; none of your "matinées"! . . .

To-day we pass through the park, and camp at the head of another canyon.

JUNE 7    To-day two or three of us climb to the summit of the cliff on the left, and find its altitude above camp to be 2,086 feet. The rocks are split with fissures, deep and narrow, sometimes a hundred feet or more to the bottom, and these fissures are filled with loose earth and decayed vegetation in which lofty pines find root. On a rock we find a pool of clear, cold water, caught from yesterday evening's shower. After a good drink we walk out to the brink of the canyon and look down to the water below. I can do this now, but it has taken several years of mountain climbing to cool my nerves so that I can sit with my feet over the edge and calmly look down a precipice 2,000 feet. And yet I cannot look on and see another do the same. I must either bid him come away or turn my head. The canyon walls are buttressed on a grand scale, with deep alcoves intervening; columned crags crown the cliffs, and the river is rolling below.

When we return to camp at noon the sun shines in splendor on vermilion walls, shaded into green and gray where the rocks are lichened over; the river fills the channel from wall to wall, and the canyon opens, like a beautiful portal, to a region of glory. This evening, as I write, the sun is going down and the shadows are settling in the canyon. The vermilion gleams and roseate hues, blending with the green and gray tints, are slowly changing to somber brown above, and black shadows are creeping over them below; and now it is a dark portal to a region of gloom—the gateway through which we are to enter on our voyage of exploration to-morrow. What shall we find?

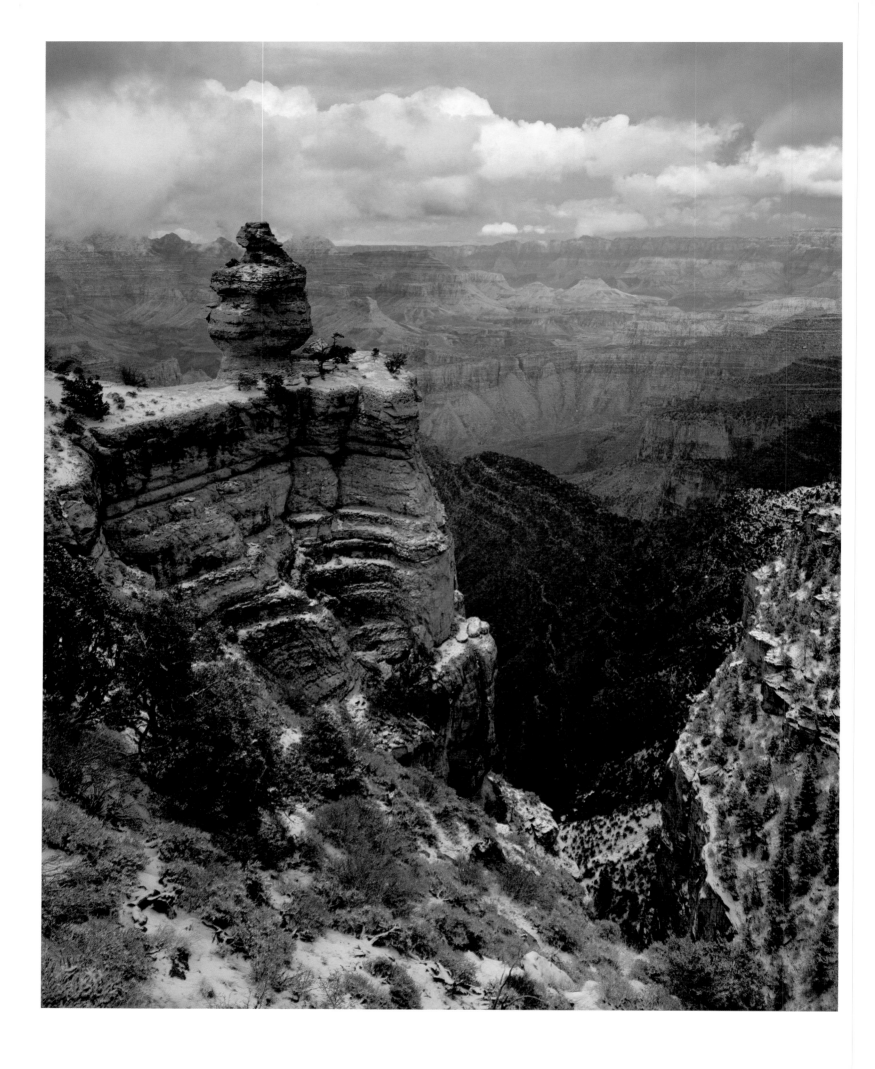

## Raft the San Juan

*The Escalante and the San Juan Rivers are the two major tributaries of the Colorado in the region of Glen Canyon. The Escalante is on the Colorado's former right bank, the San Juan on its left. The drainages are very different in character: the Escalante has more regions that I would call elegant, but the San Juan has its share of magic.*

*I rafted the San Juan in May of 1992, after an unusually wet winter. It was another of many memorable trips with my great friend Steve Andersen. The higher-than-average snowmelt was augmented by daily thundershowers, giving the river up to 9,000 cubic feet per second of flow and allowing us to cover the requisite distance each day without a lot of rowing. The San Juan has virtually no whitewater—I saw only one spot where the river might flip a boat if you really tried.*

*The first part of the trip is notable for an abundance of petroglyphs, which we often stopped to examine, but it was farther downstream that I found what I sought. In a region of the canyon with a remarkable uniformity of geologic strata, a trail climbs 1,500 feet to the rim of the canyon. The fabulous view from the top of this trail includes Monument Valley, clearly visible just 15 miles to the south. The trail includes sections that require cautious attention, lest a loss of footing send one sliding down a scree slope and then over a several-hundred-foot cliff. We camped at the base of the trail, and I climbed to a favorite spot several times to make photographs in different light of the river winding its way into the distance. My favorite among the many results, on pages 16–17, conjures thoughts of Powell and his men on their voyage into the unknown.*

*Farther along, at Slickhorn Gulch, I had the chance to make a rare daytime large-format photograph of lightning. The combination of relatively short daytime exposures, rapid movement of the storm, the highly unpredictable form and occurrence of lightning, the complexity of view camera composition, and heavy rain makes such an image highly unlikely. As late afternoon and a heavy, stormy sky dimmed the light, a cell rich with lightning passed close to the north, and on one of three exposures of about eight seconds duration each, I was successful. I quickly retired to the tent to dry my camera before it suffered much harm. Inspection of the transparency with a loupe reveals that the main bolt is actually five or six separate bolts in perfect parallel—the lightning pulsed very quickly as the air through which it was flowing moved. More than a dozen barely visible tentacles of lightning can be seen filling the clouds.*

*Upon entering the last of four distinct geomorphological regions of the canyon, I was astonished to discover what appeared to be Glen Canyon itself. In fact, Eliot Porter made several images for* The Place No One Knew *here on the San Juan. As we floated downriver on that next-to-last day, we passed many lovely, ephemeral waterfalls, the results of the previous day's rain. Side canyons showed obvious evidence of flooding the night before, and nowhere could we see a place to camp: the river went nearly wall-to-wall.*

*After many miles of looking we stopped to camp at Oljeto Wash—the very spot where Porter had made his splendid photograph,* The Wall at Moonlight Creek. *The mouth of this side canyon was about 70 yards wide, and the overhanging wall on the right towered 800 feet over the canyon bottom. The canyon narrowed to about 25 yards across at the closest bend, and there, just in view, was a good-sized sandbar, at its highest point less than 3 feet above the stream.*

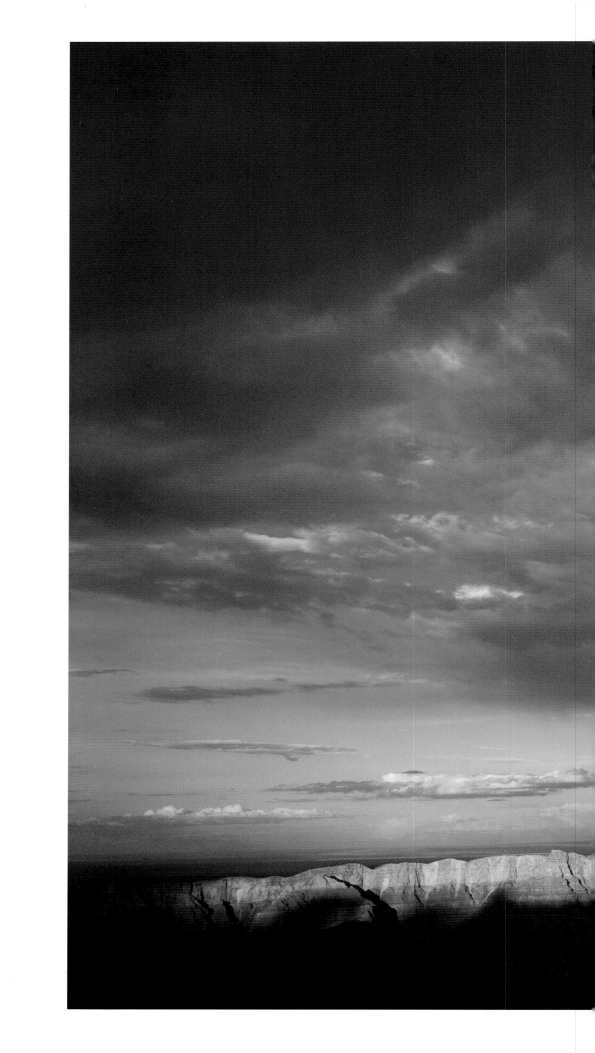

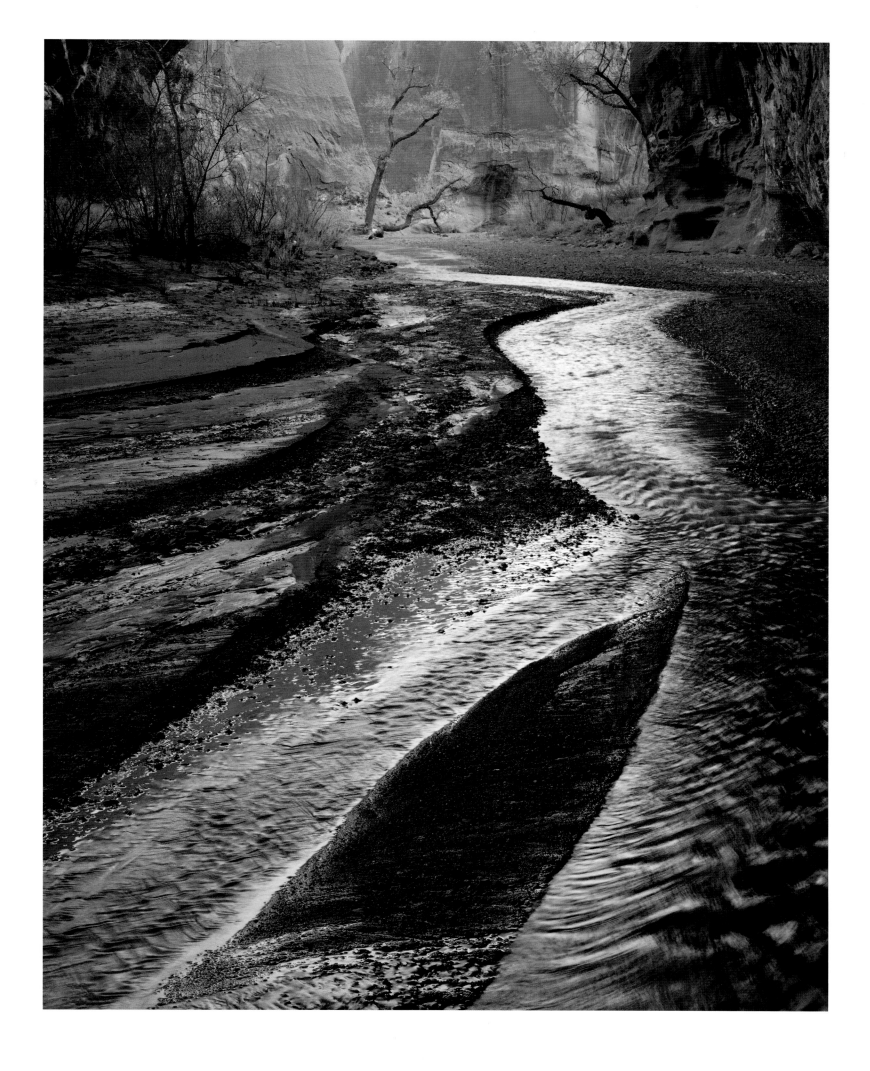

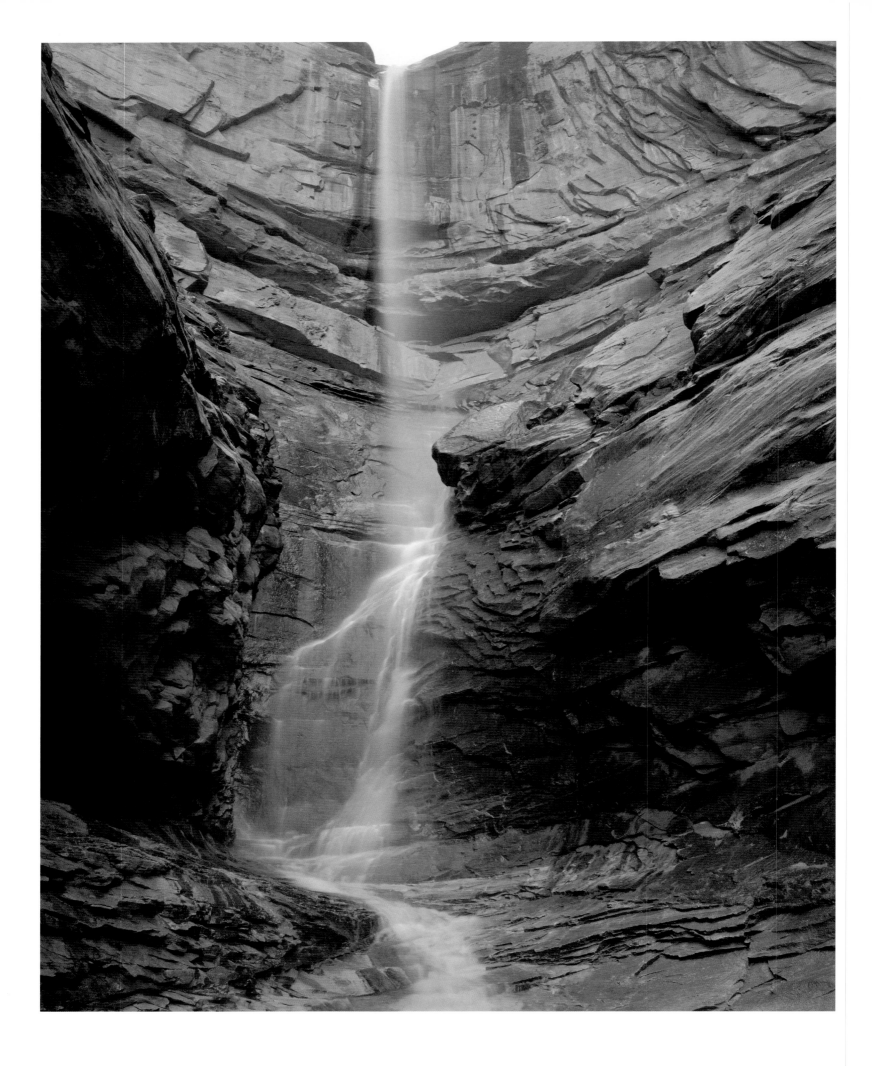

sits on a rock and holds the boat until the others are ready to pull, then gives the boat a push, clings to it with his hands, and climbs in as they pull for mainland, which they reach in safety. We are as glad to shake hands with them as though they had been on a voyage around the world and wrecked on a distant coast.

Down the river half a mile we find that the after cabin of the wrecked boat, with a part of the bottom, ragged and splintered, has floated against a rock and stranded. There are valuable articles in the cabin; but, on examination, we determine that life should not be risked to save them. Of course, the cargo of rations, instruments, and clothing is gone.

We return to the boats and make camp for the night. No sleep comes to me in all those dark hours. The rations, instruments, and clothing have been divided among the boats, anticipating such an accident as this; and we started with duplicates of everything that was deemed necessary to success. But, in the distribution, there was one exception to this precaution—the barometers were all placed in one boat, and they are lost! There is a possibility that they are in the cabin lodged against the rock, for that is where they were kept. But, then, how to reach them? The river is rising. Will they be there to-morrow? Can I go out to Salt Lake City and obtain barometers from New York?

JUNE 10   I have determined to get the barometers from the wreck, if they are there. After breakfast, while the men make the portage, I go down again for another examination. There the cabin lies, only carried 50 or 60 feet farther on. Carefully looking over the ground, I am satisfied that it can be reached with safety, and return to tell the men my conclusion. Sumner and Dunn volunteer to take the little boat and make the attempt. They start, reach it, and out come the barometers! The boys set up a shout, and I join them, pleased that they should be as glad as myself to save the instruments. When the boat lands on our side, I find that the only things saved from the wreck were the barometers, a package of thermometers, and a three-gallon keg of whiskey. The last is what the men were shouting about. They had taken it aboard unknown to me, and now I am glad they did take it, for it will do them good, as they are drenched every day by the melting snow which runs down from the summits of the Rocky Mountains. . . .

JUNE 11   This day is spent in carrying our rations down to the bay—no small task, climbing over the rocks with sacks of flour and bacon. We carry them by stages of about 500 yards each, and when night comes and the last sack is on the beach, we are tired, bruised, and glad to sleep.

JUNE 13   Rocks, rapids, and portages still. We camp to-night at the foot of the left fall, on a little patch of flood plain covered with a dense growth of box-elders, stopping early in order to spread the clothing and rations to dry. Everything is wet and spoiling.

JUNE 15   . . . We have three falls in close succession. At the first the water is compressed into a very narrow channel against the right-hand cliff, and falls 15 feet in 10 yards. At the second we have a broad sheet of water tumbling down 20 feet over a group of rocks that thrust their dark heads through the foam. The third is a broken fall, or short, abrupt rapid, where the water makes a descent of more than 20 feet among huge, fallen fragments of the cliff. We name the group Triplet Falls. We make a portage around the first; past the second and the third we let down with lines.

During the afternoon, . . . we run down three quarters of a mile on quiet waters and land at the head of another fall. On examination, we find that there is an abrupt plunge of a few feet and then the river tumbles for half a mile with a descent of a hundred feet, in a channel beset with great numbers of huge boulders. This stretch of the river is named Hell's Half-Mile. The remaining portion of the day is occupied in making a trail among the rocks at the foot of the rapid.

JUNE 16  Our first work this morning is to carry our cargoes to the foot of the falls. Then we commence letting down the boats. . . .

. . . We are letting down the last boat, and as she is set free a wave turns her broadside down the stream, with the stem, to which the line is attached, from shore and a little up. They haul on the line to bring the boat in, but the power of the current, striking obliquely against her, shoots her out into the middle of the river. The men have their hands burned with the friction of the passing line; the boat breaks away and speeds with great velocity down the stream. The "Maid of the Canyon" is lost! So it seems; but she drifts some distance and swings into an eddy, in which she spins about until we arrive with the small boat and rescue her.

Soon we are on our way again, and stop at the mouth of a little brook on the right for a late dinner. This brook comes down from the distant mountains in a deep side canyon. We set out to explore it, but are soon cut off from farther progress up the gorge by a high rock, over which the brook glides in a smooth sheet. The rock is not quite vertical, and the water does not plunge over it in a fall.

Then we climb up to the left for an hour, and are 1,000 feet above the river and 600 above the brook. Just before us the canyon divides, a little stream coming down on the right and another on the left, and we can look away up either of these canyons, through an ascending vista, to cliffs and crags and towers a mile back and 2,000 feet overhead. To the right a dozen gleaming cascades are seen. Pines and firs stand on the rocks and aspens overhang the brooks. The rocks below are red and brown, set in deep shadows, but above they are buff and vermilion and stand in the sunshine. The light above, made more brilliant by the bright-tinted rocks, and the shadows below, more gloomy by reason of the somber hues of the brown walls, increase the apparent depths of the canyons, and it seems a long way up to the world of sunshine and open sky, and a long way down to the bottom of the canyon glooms.

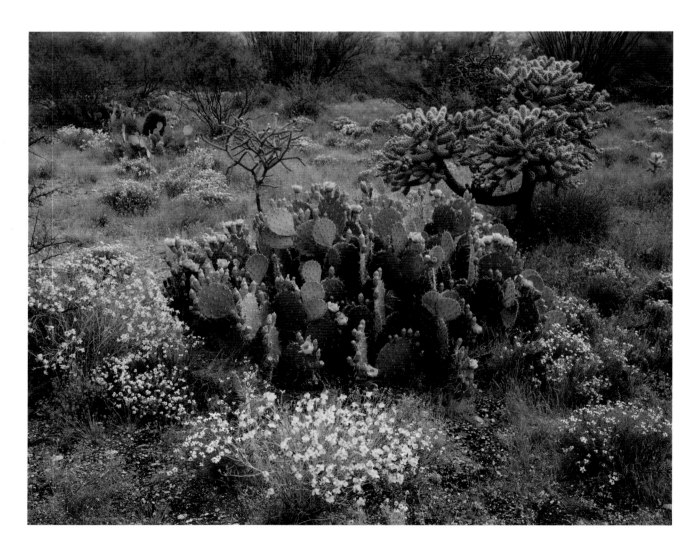

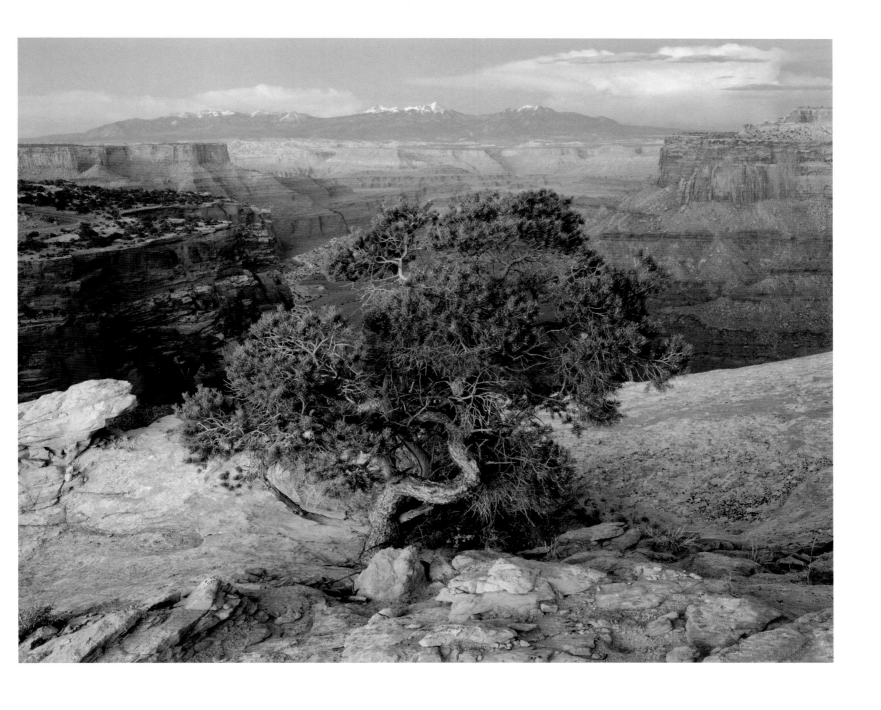

Never before have I received such an impression of the vast heights of these canyon walls, not even at the Cliff of the Harp, where the very heavens seemed to rest on their summits. We sit on some overhanging rocks and enjoy the scene for a time, listening to the music of the falling waters away up the canyon. We name this Rippling Brook.

Late in the afternoon we make a short run to the mouth of another little creek, coming down from the left into an alcove filled with luxuriant vegetation. Here camp is made, with a group of cedars on one side and a dense mass of box-elders and dead willows on the other.

I go up to explore the alcove. While away a whirlwind comes and scatters the fire among the dead willows and cedar-spray, and soon there is a conflagration. The men rush for the boats, leaving all they cannot readily seize at the moment, and even then they have their clothing burned and hair singed, and Bradley has his ears scorched. The cook fills his arms with the mess-kit, and jumping into a boat, stumbles and falls, and away go our cooking utensils into the river. Our plates are gone; our spoons are gone; our knives and forks are gone. . . .

When on the boats, the men are compelled to cut loose, as the flames, running out on the overhanging willows, are scorching them. Loose on the stream, they must go down, for the water is too swift to make headway against it. Just below is a rapid, filled with rocks. On the shoot, no channel explored, no signal to guide them! Just at this juncture I chance to see them, but have not yet discovered the fire, and the strange movements of the men fill me with astonishment. Down the rocks I clamber, and run to the bank. When I arrive they have landed. Then we all go back to the late camp to see if anything left behind can be saved. Some of the clothing and bedding taken out of the boats is found, also a few tin cups, basins, and a camp kettle; and this is all the mess-kit we now have. Yet we do just as well as ever.

JUNE 17  We run down to the mouth of Yampa River. This has been a chapter of disasters and toils, notwithstanding which the Canyon of Lodore was not devoid of scenic interest, even beyond the power of pen to tell. The roar of its waters was heard unceasingly from the hour we entered it until we landed here. No quiet in all that time. But its walls and cliffs, its peaks and crags, its amphitheaters and alcoves, tell a story of beauty and grandeur that I hear yet—and shall hear. . . .

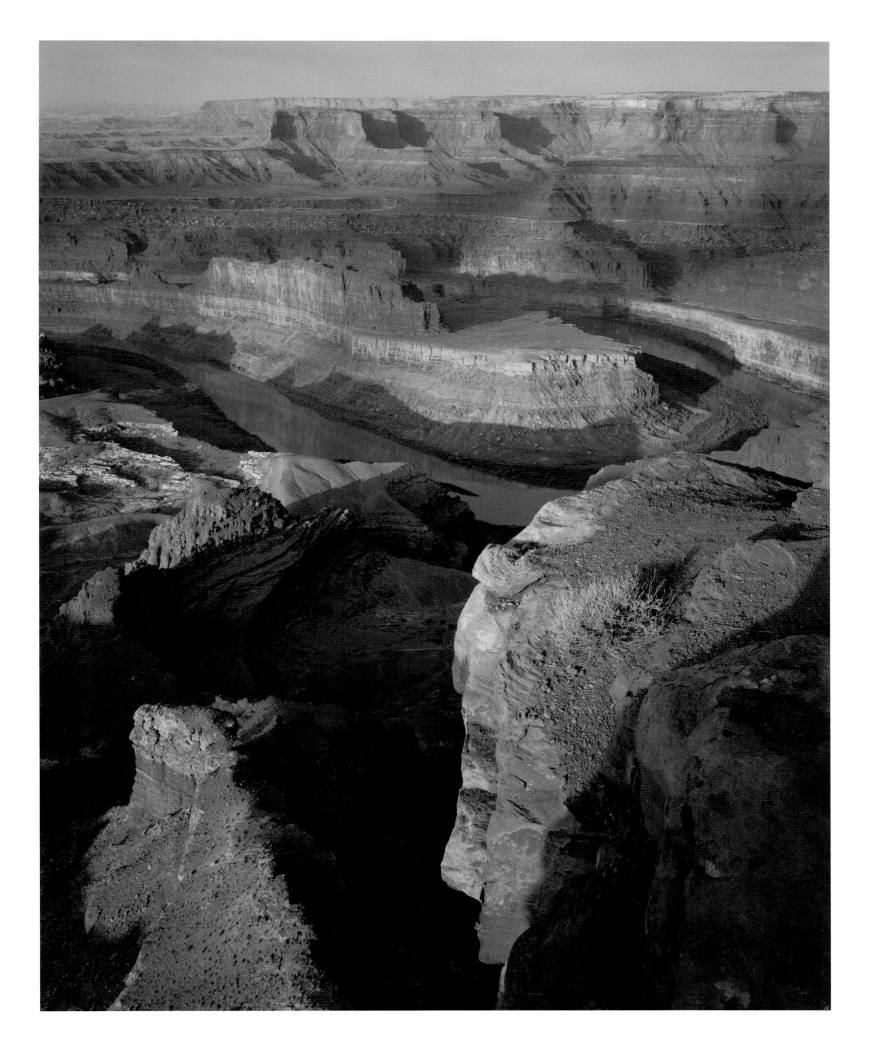

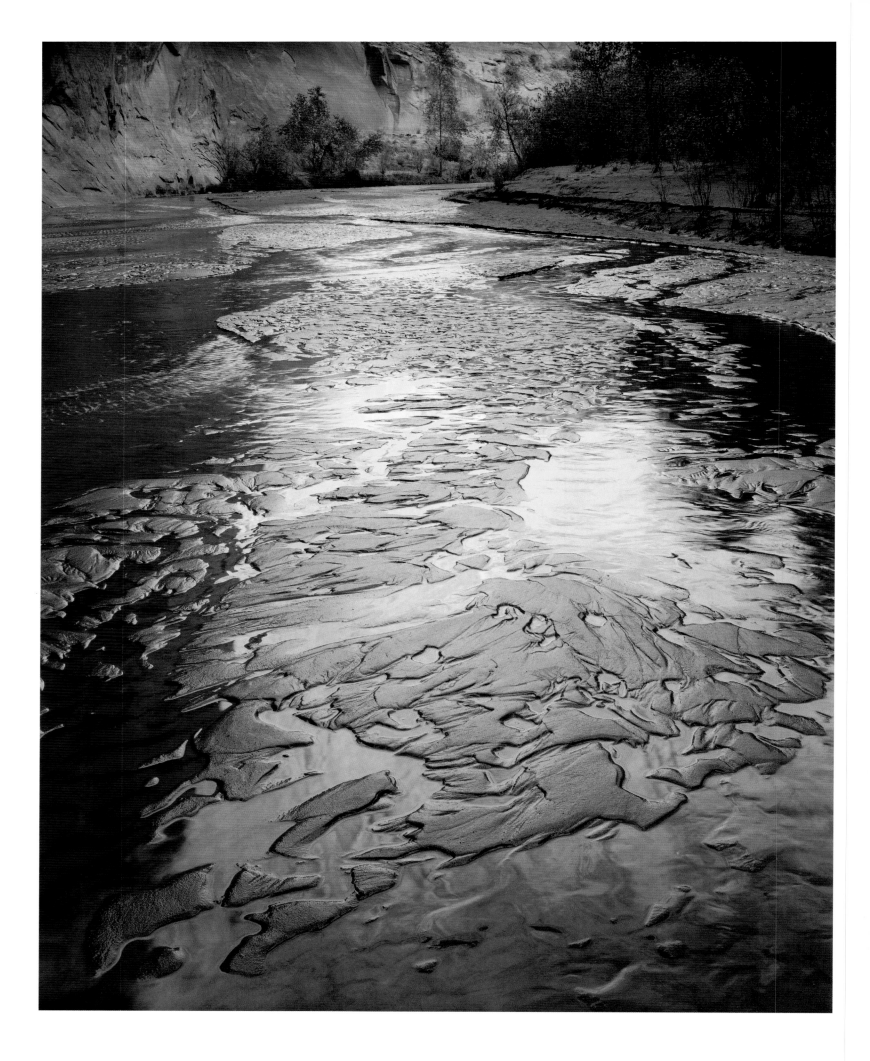

## The Mystery of the Cycling Waters

*I once happened upon a curiosity which I have been unable to explain to this day. I have long been known for loving mud. Actually, what I love are the patterns and reflections that I find in the beds of rivers and streams, where the water has formed a rippling surface of sediment. The central basin of the Colorado excels in such muds, actually made of very fine sands. On one knapsack trip in 1985 I came upon a delightfully promising scene. I quickly began to create a composition consisting mainly of the streambed I had been walking up, but while looking at the dim and inverted image on the ground glass of the camera, I noticed that the patterns had mostly vanished. Standing up, I saw that the stream flow had increased, and the patterns I had enjoyed were mostly inundated and no longer of artistic interest. I began to put the gear away to continue hiking, but when I glanced back at the stream I saw the patterns begin to reappear. Out came the camera again. I discovered that every twelve minutes the stream would cycle up and down, approximately doubling, then halving, its flow. I watched it complete five cycles, and made several variations of the image at different water heights. No wind blew either up- or down-canyon. No gushing spring existed upstream with its own mysterious cycle. No earthquake in progress. No cyclical, local shifting of the force of gravity. No way to explain it.*

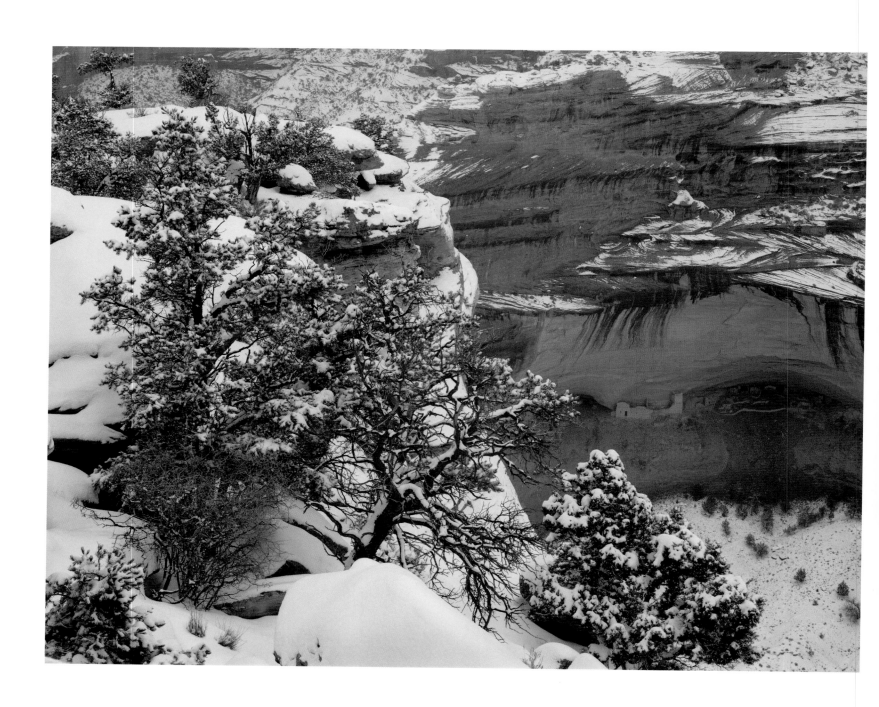

# FROM ECHO PARK
# TO THE MOUTH OF THE UINTA RIVER

JUNE 18   We have named the long peninsular rock on the other side Echo Rock. Desiring to climb it, Bradley and I take the little boat and pull up stream as far as possible, for it cannot be climbed directly opposite. We land on a talus of rocks at the upper end in order to reach a place where it seems practicable to make the ascent; but we find we must go still farther up the river. So we scramble along, until we reach a place where the river sweeps against the wall. Here we find a shelf along which we can pass, and now are ready for the climb.

We start up a gulch; then pass to the left on a bench along the wall; then up again over broken rocks; then we reach more benches, along which we walk, until we find more broken rocks and crevices, by which we climb; still up, until we have ascended 600 or 800 feet, when we are met by a sheer precipice. Looking about, we find a place where it seems possible to climb. I go ahead; Bradley hands the barometer to me, and follows. So we proceed, stage by stage, until we are nearly to the summit. Here, by making a spring, I gain a foothold in a little crevice, and grasp an angle of the rock overhead. I find I can get up no farther and cannot step back, for I dare not let go with my hand and cannot reach foothold below without. I call to Bradley for help. He finds a way by which he can get to the top of the rock over my head, but cannot reach me. Then he looks around for some stick or limb of a tree, but finds none. Then he suggests that he would better help me with the barometer case, but I fear I cannot hold on to it. The moment is critical. Standing on my toes, my muscles begin to tremble. It is sixty or eighty feet to the foot of the precipice. If I lose my hold I shall fall to the bottom and then perhaps roll over the bench and tumble still farther down the cliff. At this instant it occurs to Bradley to take off his drawers, which he does, and swings them down to me. I hug close to the rock, let go with my hand, seize the dangling legs, and with his assistance am enabled to gain the top.

Then we walk out on the peninsular rock, make the necessary observations for determining its altitude above camp, and return, finding an easy way down.

JUNE 20   This morning two of the men take me up the Yampa for a short distance, and I go out to climb. Having reached the top of the canyon, I walk over long stretches of naked sandstone, crossing gulches now and then, and by noon reach the summit of Mount Dawes. From this point I can look away to the north and see in the dim distance the Sweetwater and Wind River mountains, more than 100 miles away. To the northwest the Wasatch Mountains are in view, and peaks of the Uinta. To the east I can see the western slopes of the Rocky Mountains, more than 150 miles distant. The air is singularly clear to-day; mountains and buttes stand in sharp outline, valleys stretch out in perspective, and I can look down into the deep canyon gorges and see gleaming waters.

Descending, I cross to a ridge near the brink of the Canyon of Lodore, the highest point of which is nearly as high as the last mentioned mountain. Late in the afternoon I stand on this elevated point and discover a monument that has evidently been built by human hands. A few plants are growing in the joints between the rocks, and all are lichened over to a greater or less extent, giving evidence that the pile was built a long time ago. This line of peaks, the eastern extension of the Uinta Mountains, has received the name of Sierra Escalante, in honor of a Spanish priest who traveled in this region of country nearly a century ago. Perchance the reverend father built this monument.

Now I return to the river and discharge my gun, as a signal for the boat to come and take me down to camp. While we have been in the park the men have succeeded in catching a number of fish, and we have an abundant supply. This is a delightful addition to our *menu*.

47

JUNE 21   We float around the long rock and enter another canyon. The walls are high and vertical, the canyon is narrow, and the river fills the whole space below, so that there is no landing-place at the foot of the cliff. The Green is greatly increased by the Yampa, and we now have a much larger river. All this volume of water, confined, as it is, in a narrow channel and rushing with great velocity, is set eddying and spinning in whirlpools by projecting rocks and short curves, and the waters waltz their way through the canyon, making their own rippling, rushing, roaring music. The canyon is much narrower than any we have seen. We manage our boats with difficulty. They spin about from side to side and we know not where we are going, and find it impossible to keep them headed down the stream. At first this causes us great alarm, but we soon find there is little danger, and that there is a general movement or progression down the river, to which this whirling is but an adjunct—that it is the merry mood of the river to dance through this deep, dark gorge, and right gaily do we join in the sport.

But soon our revel is interrupted by a cataract; its roaring command is heeded by all our power at the oars, and we pull against the whirling current. The "Emma Dean" is brought up against a cliff about 50 feet above the brink of the fall. By vigorously plying the oars on the side opposite the wall, as if to pull up stream, we can hold her against the rock. The boats behind are signaled to land where they can. The "Maid of the Canyon" is pulled to the left wall, and, by constant rowing, they can hold her also. The "Sister" is run into an alcove on the right, where an eddy is in a dance, and in this she joins. Now my little boat is held against the wall only by the utmost exertion, and it is impossible to make headway against the current. On examination, I find a horizontal crevice in the rock, about 10 feet above the water and a boat's length below us; so we let her down to that point. One of the men clambers into the crevice, into which he can just crawl; we toss him the line, which he makes fast in the rocks, and now our boat is tied up. Then I follow into the crevice and we crawl along up stream a distance of 50 feet or more, and find a broken place where we can climb about 50 feet higher. Here we stand on a shelf that passes along down stream to a point above the falls, where it is broken down, and a pile of rocks, over which we can descend to the river, is lying against the foot of the cliff.

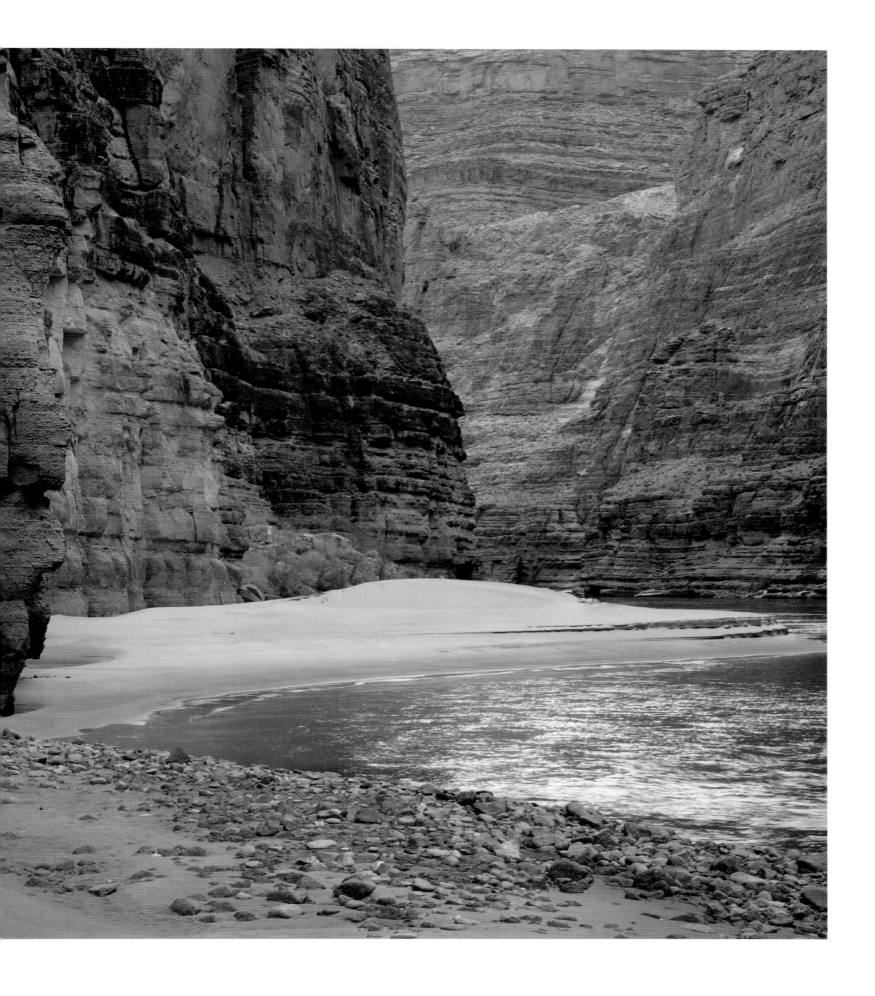

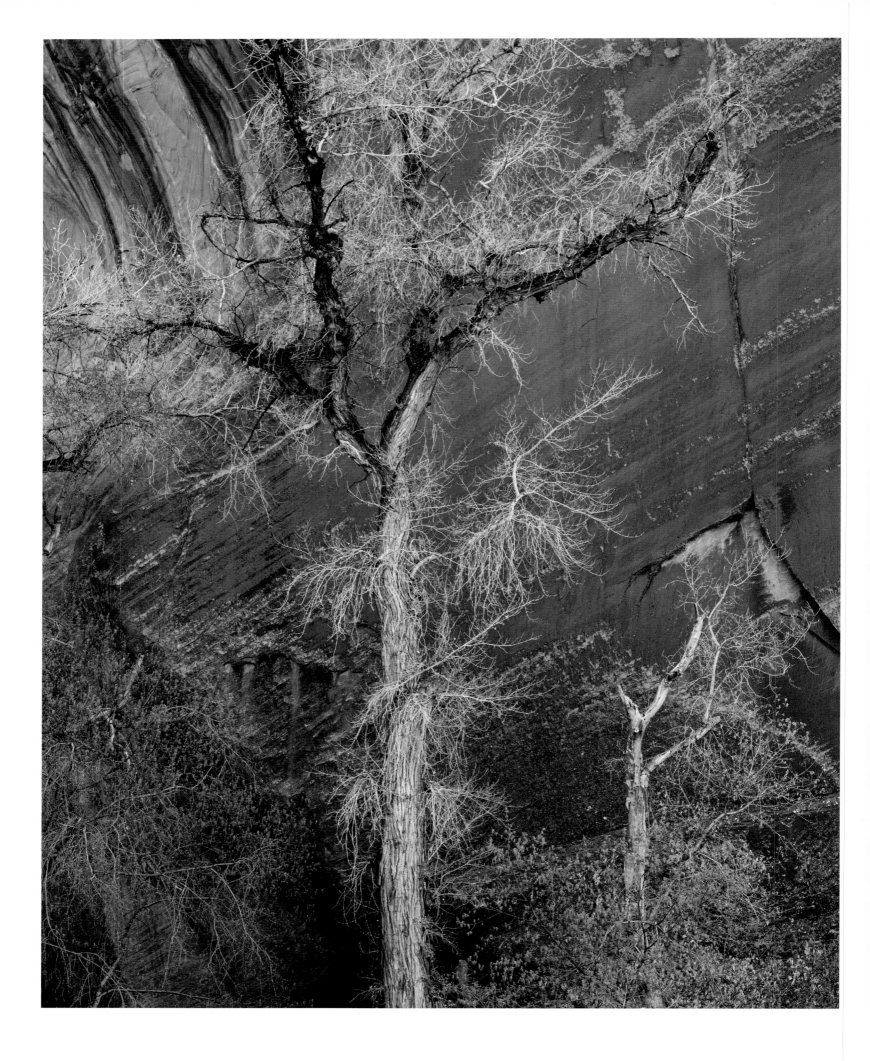

It has been mentioned that one of the boats is on the other side. I signal for the men to pull her up alongside of the wall, but it cannot be done; then to cross. This they do, gaining the wall on our side just above where the "Emma Dean" is tied.

The third boat is out of sight, whirling in the eddy of a recess. Looking about, I find another horizontal crevice, along which I crawl to a point just over the water where this boat is lying, and, calling loud and long, I finally succeed in making the crew understand that I want them to bring the boat down, hugging the wall. This they accomplish by taking advantage of every crevice and knob on the face of the cliff, so that we have the three boats together at a point a few yards above the falls. Now, by passing a line up on the shelf, the boats can be let down to the broken rocks below. This we do, and, making a short portage, our troubles here are over.

Below the falls the canyon is wider, and there is more or less space between the river and the walls; but the stream, though wide, is rapid, and rolls at a fearful rate among the rocks. We proceed with great caution, and run the large boats wholly by signal.

At night we camp at the mouth of a small creek, which affords us a good supper of trout. . . .

JUNE 22   Still making short portages and letting down with lines. While we are waiting for dinner to-day, I climb a point that gives me a good view of the river for two or three miles below, and I think we can make a long run. After dinner we start; the large boats are to follow in fifteen minutes and look out for the signal to land. Into the middle of the stream we row, and down the rapid river we glide, only making strokes enough with the oars to guide the boat. What a headlong ride it is! shooting past rocks and islands. I am soon filled with exhilaration only experienced before in riding a fleet horse over the outstretched prairie. One, two, three, four miles we go, rearing and plunging with the waves, until we wheel to the right into a beautiful park and land on an island, where we go into camp.

An hour or two before sunset I cross to the mainland and climb a point of rocks where I can overlook the park and its surroundings. On the east it is bounded by a high mountain ridge. A semicircle of naked hills bounds it on the north, west, and south.

The broad, deep river meanders through the park, interrupted by many wooded islands; so I name it Island Park, and decide to call the canyon above, Whirlpool Canyon.

JUNE 23   We remain in camp to-day to repair our boats, which have had hard knocks and are leaking. Two of the men go out with the barometer to climb the cliff at the foot of Whirlpool Canyon and measure the walls; another goes on the mountain to hunt; and Bradley and I spend the day among the rocks, studying an interesting geologic fold and collecting fossils. Late in the afternoon the hunter returns and brings with him a fine, fat deer; so we give his name to the mountain—Mount Hawkins. Just before night we move camp to the lower end of the park, floating down the river about four miles.

JUNE 25   This morning we enter Split Mountain Canyon, sailing in through a broad, flaring, brilliant gateway. We run two or three rapids, after they have been carefully examined. Then we have a series of six or eight, over which we are compelled to pass by letting the boats down with lines. This occupies the entire day, and we camp at night at the mouth of a great cave. The cave is at the foot of one of these rapids, and the waves dash in nearly to its end. We can pass along a little shelf at the side until we reach the back part. Swallows have built their nests in the ceiling, and they wheel in, chattering and scolding at our intrusion; but their clamor is almost drowned by the noise of the waters. Looking out of the cave, we can see, far up the river, a line of crags standing sentinel on either side, and Mount Hawkins in the distance.

JUNE 26   The forenoon is spent in getting our large boats over the rapids. This afternoon we find three falls in close succession. We carry our rations over the rocks and let our boats shoot over the falls, checking and bringing them to land with lines in the eddies below. At three o'clock we are all aboard again. Down the river we are carried by the swift waters at great speed, sheering around a rock now and then with a timely stroke or two of the oars. At one point the river turns from left to right, in a direction at right angles to the canyon, in a long chute and strikes the right, where its waters are heaped up in great billows that tumble back in breakers. We glide into the chute before we see the danger, and it is too late to stop. Two or three hard strokes are given on the right and we pause for an instant, expecting to be dashed against the rock. But the bow of the boat leaps high on a great wave, the rebounding waters hurl us back, and the peril is past. The next moment the other boats are hurriedly signaled to land on the left. Accomplishing this, the men walk along the shore, holding the boats near the bank, and let them drift around. Starting again, we soon debouch into a beautiful valley, glide down its length for 10 miles, and camp under a grand old cottonwood. This is evidently a frequent resort for Indians. Tent poles are lying about, and the dead embers of late camp fires are seen. On the plains to the left, antelope are feeding. Now and then a wolf is seen, and after dark they make the air resound with their howling.

JUNE 27   Now our way is along a gently flowing river, beset with many islands; groves are seen on either side, and natural meadows, where herds of antelope are feeding. Here and there we have views of the distant mountains on the right. During the afternoon we make a long detour to the west and return again to a point not more than half a mile from where we started at noon, and here we camp for the night under a high bluff.

JUNE 28   To-day the scenery on either side of the river is much the same as that of yesterday, except that two or three lakes are discovered, lying in the valley to the west. After dinner we run but a few minutes when we discover the mouth of the Uinta, a river coming in from the west. Up the valley of this stream about 40 miles the reservation of the Uinta Indians is situated. We propose to go there and see if we can replenish our mess-kit, and perhaps send letters to friends. We also desire to establish an astronomic station here; and hence this will be our stopping place for several days. . . .

JUNE 30   We have a row up the Uinta to-day, but are not able to make much headway against the swift current, and hence conclude we must walk all the way to the agency.

JULY 1   Two days have been employed in obtaining the local time, taking observations for latitude and longitude, and making excursions into the adjacent country. This morning, with two of the men, I start for the agency. It is a toilsome walk, 20 miles of the distance being across a sand desert. Occasionally we have to wade the river, crossing it back and forth. Toward evening we cross several beautiful streams, tributaries of the Uinta, and pass through pine groves and meadows, arriving at the reservation just at dusk. Captain Dodds, the agent, is away, having gone to Salt Lake City, but his assistants receive us very kindly. It is rather pleasant to see a house once more, and some evidences of civilization. . . .

JULY 5   . . . Frank Goodman informs me this morning that he has concluded not to go on with the party, saying that he has seen danger enough. It will be remembered that he was one of the crew on the "No Name" when she was wrecked. As our boats are rather heavily loaded, I am content that he should leave, although he has been a faithful man.

We start early on our return to the boats, taking horses with us from the reservation, and two Indians, who are to bring the animals back. . . .

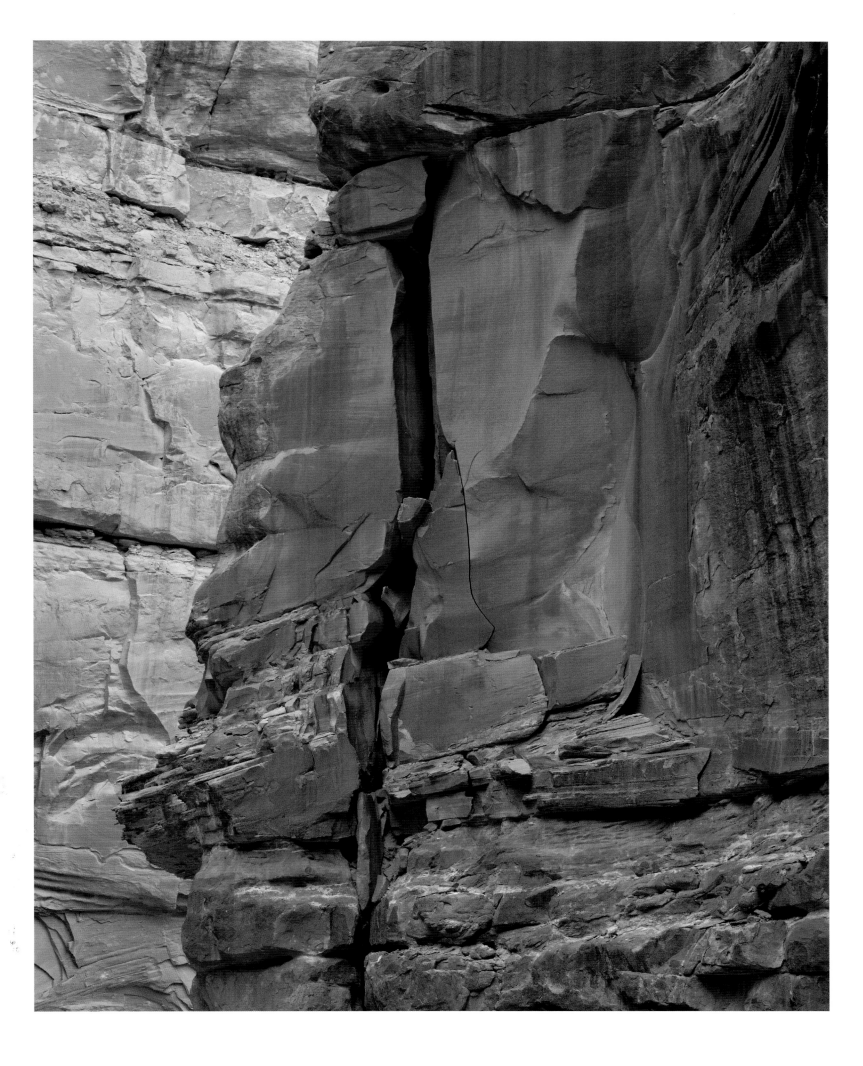

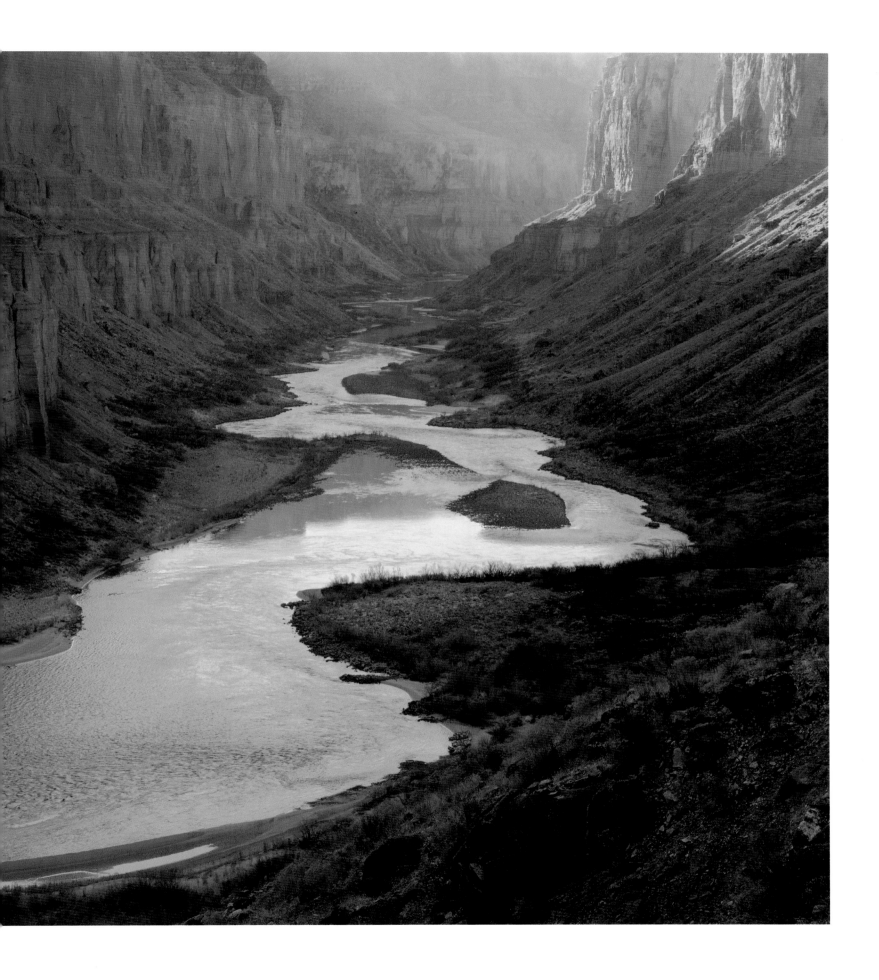

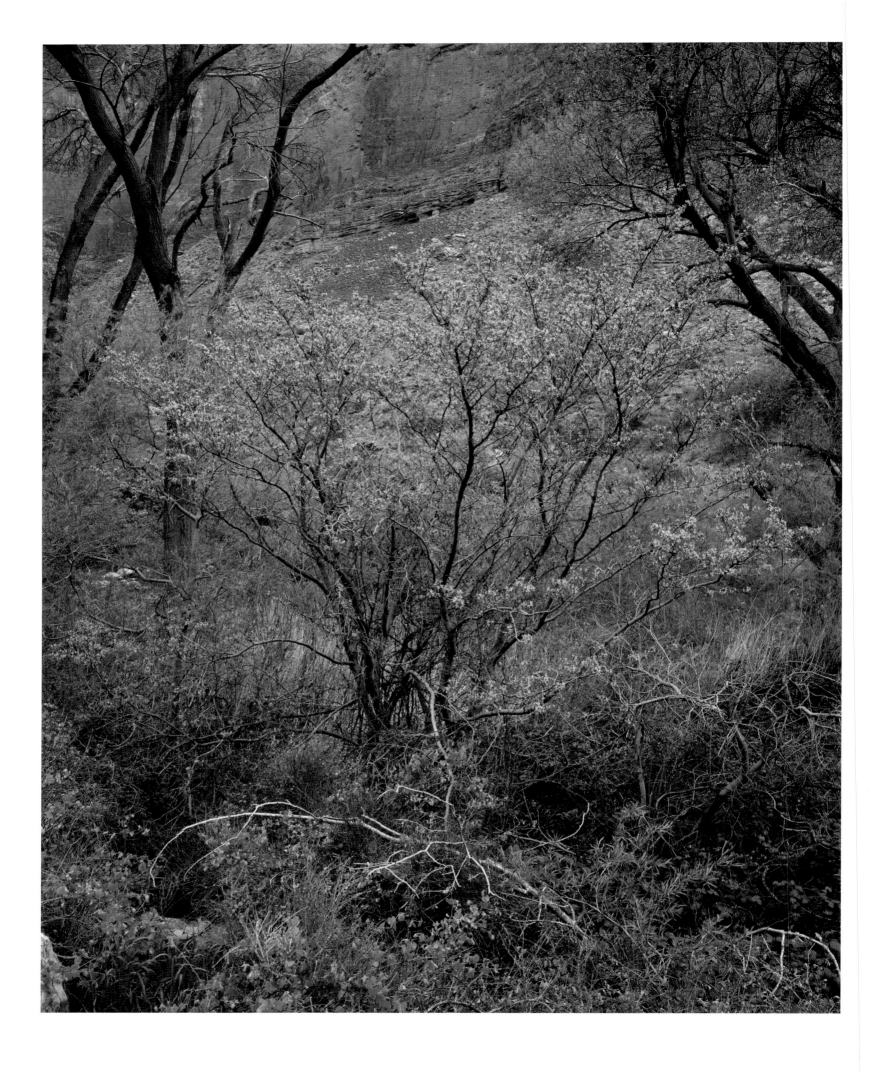

JULY 7   We find quiet water to-day, the river sweeping in great and beautiful curves, the canyon walls steadily increasing in altitude. The escarpments formed by the cut edges of the rock are often vertical, sometimes terraced, and in some places the treads of the terraces are sloping. In these quiet curves vast amphitheaters are formed, now in vertical rocks, now in steps.

The salient point of rock within the curve is usually broken down in a steep slope, and we stop occasionally to climb up at such a place, where on looking down we can see the river sweeping the foot of the opposite cliff in a great, easy curve, with a perpendicular or terraced wall rising from the water's edge many hundreds of feet. One of these we find very symmetrical and name it Sumner's Amphitheater. The cliffs are rarely broken by the entrance of side canyons, and we sweep around curve after curve with almost continuous walls for several miles.

Late in the afternoon we find the river very much rougher and come upon rapids, not dangerous, but still demanding close attention. We camp at night on the right bank, having made 26 miles.

JULY 8   . . . After dinner we pass through a region of the wildest desolation. The canyon is very tortuous, the river very rapid, and many lateral canyons enter on either side. These usually have their branches, so that the region is cut into a wilderness of gray and brown cliffs. In several places these lateral canyons are separated from one another only by narrow walls, often hundreds of feet high,—so narrow in places that where softer rocks are found below they have crumbled away and left holes in the wall, forming passages from one canyon into another. These we often call natural bridges; but they were never intended to span streams. They would better, perhaps, be called side doors between canyon chambers. Piles of broken rock lie

against these walls; crags and tower-shaped peaks are seen everywhere, and away above them, long lines of broken cliffs; and above and beyond the cliffs are pine forests, of which we obtain occasional glimpses as we look up through a vista of rocks. The walls are almost without vegetation; a few dwarf bushes are seen here and there clinging to the rocks, and cedars grow from the crevices—not like the cedars of a land refreshed with rains, great cones bedecked with spray, but ugly clumps, like war clubs beset with spines. We are minded to call this the Canyon of Desolation.

The wind annoys us much to-day. The water, rough by reason of the rapids, is made more so by head gales. Wherever a great face of rocks has a southern exposure, the rarefied air rises and the wind rushes in below, either up or down the canyon, or both, causing local currents. Just at sunset we run a bad rapid and camp at its foot.

JULY 9   Our run to-day is through a canyon with ragged, broken walls, many lateral gulches or canyons entering on either side. The river is rough, and occasionally it becomes necessary to use lines in passing rocky places. During the afternoon we come to a rather open canyon valley, stretching up toward the west, its farther end lost in the mountains. From a point to which we climb we obtain a good view of its course, until its angular walls are lost in the vista.

JULY 11   A short distance below camp we run a rapid, and in doing so break an oar and then lose another, both belonging to the "Emma Dean." Now the pioneer boat has but two oars. We see nothing from which oars can be made, so we conclude to run on to some point where it seems possible to climb out to the forests on the plateau, and there we will procure suitable timber from which to make new ones.

We soon approach another rapid. Standing on deck, I think it can be run, and on we go. Coming nearer, I see that at the foot it has a short turn to the left, where the waters pile up against the cliff. Here we try to land, but quickly discover that, being in swift water above the fall, we cannot reach shore, crippled as we are by the loss of two oars; so the bow of the boat is turned down stream. We shoot by a big rock; a reflex wave rolls over our little boat and fills her. I see that the place is dangerous and quickly signal to the other boats to land where they can. This is scarcely completed when another wave rolls our boat over and I am thrown some distance into the water. I soon

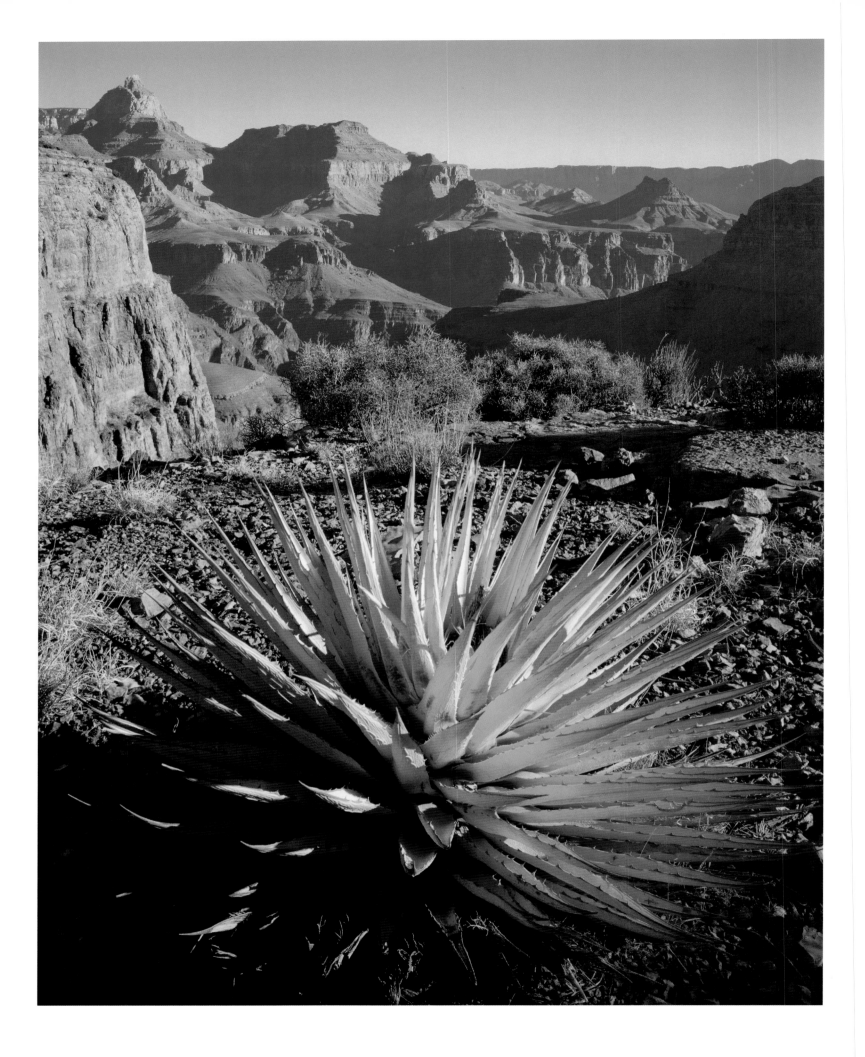

find that swimming is very easy and I cannot sink. It is only necessary to ply strokes sufficient to keep my head out of the water, though now and then, when a breaker rolls over me, I close my mouth and am carried through it. The boat is drifting ahead of me 20 or 30 feet, and when the great waves have passed I overtake her and find Sumner and Dunn clinging to her. As soon as we reach quiet water we all swim to one side and turn her over. In doing this, Dunn loses his hold and goes under; when he comes up he is caught by Sumner and pulled to the boat. In the meantime we have drifted down stream some distance and see another rapid below. How bad it may be we cannot tell; so we swim toward shore, pulling our boat with us, with all the vigor possible, but are carried down much faster than distance toward shore is diminished. At last we reach a huge pile of driftwood. Our rolls of blankets, two guns, and a barometer were in the open compartment of the boat and, when it went over, these were thrown out. The guns and barometer are lost, but I succeeded in catching one of the rolls of blankets as it drifted down, when we were swimming to shore; the other two are lost, and sometimes hereafter we may sleep cold.

A huge fire is built on the bank and our clothing spread to dry, and then from the drift logs we select one from which we think oars can be made, and the remainder of the day is spent in sawing them out.

JULY 12    This morning the new oars are finished and we start once more. We pass several bad rapids, making a short portage at one and before noon we come to a long, bad fall, where the channel is filled with rocks on the left which turn the waters to the right, where they pass under an overhanging rock. On examination we determine to run it, keeping as close to the left-hand rocks as safety will permit, in order to avoid the overhanging cliff. The little boat runs over all right; another follows, but the men are not able to keep her near enough to the left bank and she is carried by a swift chute into great waves to the right, where she is tossed about and Bradley is knocked over the side; his foot catching under the seat, he is dragged along in the water with his head down; making great exertion, he seizes the gunwale with his left hand and can lift his head above water now and then. To us who are below, it seems impossible to keep the boat from going under the overhanging cliff; but Powell, for the moment heedless of Bradley's mishap, pulls with all his power for half a dozen strokes, when the danger is past; then he seizes Bradley and pulls him in. The men in the boat above, seeing this, land, and she is let down by lines.

Just here we emerge from the Canyon of Desolation, as we have named it, into a more open country, which extends for a distance of nearly a mile, when we enter another canyon cut through gray sandstone. . . .

At night we camp on a sand beach. The wind blows a hurricane; the drifting sand almost blinds us; and nowhere can we find shelter. The wind continues to blow all night, the sand sifting through our blankets and piling over us until we are covered as in a snowdrift. We are glad when morning comes.

JULY 13    This morning we have an exhilarating ride. The river is swift, and there are many smooth rapids. I stand on deck, keeping careful watch ahead, and we glide along, mile after mile, plying strokes, now on the right and then on the left, just sufficient to guide our boats past the rocks into smooth water. At noon we emerge from Gray Canyon, as we have named it, and camp for dinner under a cottonwood tree standing on the left bank. . . .

This afternoon our way is through a valley with cottonwood groves on either side. The river is deep, broad, and quiet. About two hours after noon camp we discover an Indian crossing, where a number of rafts, rudely constructed of logs and bound together by withes, are floating against the bank. On landing, we see evidences that a party of Indians have crossed within a very few days. This is the place where the lamented Gunnison crossed, in the year 1853, when making an exploration for a railroad route to the Pacific coast. . . .

JULY 14    . . . The course of the river is tortuous, and it nearly doubles upon itself many times. The water is quiet, and constant rowing is necessary to make much headway. Sometimes there is a narrow flood plain between the river and the wall, on one side or the other. Where these long, gentle curves are found, the river washes the very foot of the outer wall. A long peninsula of willow-bordered meadow projects within the curve, and the talus at the foot of the cliff is usually covered with dwarf oaks. The orange-colored sandstone is homogeneous in structure, and the walls are usually vertical, though not very high. Where the river sweeps around a curve under a cliff, a vast hollow dome may be seen, with many caves and deep alcoves, which are greatly admired by the members of the party as we go by.

We camp at night on the left bank.

JULY 15 . . . On we go, . . . with quiet water, still compelled to row in order to make fair progress. The canyon is yet very tortuous. About six miles below noon camp we go around a great bend to the right, five miles in length, and come back to a point within a quarter of a mile of where we started. Then we sweep around another great bend to the left, making a circuit of nine miles, and come back to a point within 600 yards of the beginning of the bend. In the two circuits we describe almost the figure 8. The men call it a "bowknot" of river; so we name it Bowknot Bend. The line of the figure is 14 miles in length.

There is an exquisite charm in our ride to-day down this beautiful canyon. It gradually grows deeper with every mile of travel; the walls are symmetrically curved and grandly arched, of a beautiful color, and reflected in the quiet waters in many places so as almost to deceive the eye and suggest to the be- holder the thought that he is looking into profound depths. We are all in fine spirits and feel very gay, and the badinage of the men is echoed from wall to wall. Now and then we whistle or shout or discharge a pistol, to listen to the reverberations among the cliffs.

At night we camp on the south side of the great Bowknot, and as we eat supper, which is spread on the beach, we name this Labyrinth Canyon.

JULY 16 Still we go down on our winding way. Tower cliffs are passed; then the river widens out for several miles, and meadows are seen on either side between the river and the walls. We name this expansion of the river Tower Park. At two o'clock we emerge from Labyrinth Canyon and go into camp.

JULY 17 The line which separates Labyrinth Canyon from the one below is but a line, and at once, this morning, we enter another canyon. The water fills the entire channel, so that nowhere is there room to land. The walls are low, but vertical, and as we proceed they gradually increase in altitude. Running a couple of miles, the river changes its course many degrees toward the east. Just here a little stream comes in on the right and the wall is broken down; so we land and go out to take a view of the surrounding country. We are now down among the buttes, and in a region the surface of which is naked, solid rock—a beautiful red sandstone, forming a smooth, undulating pavement. The Indians call this the *Toom'pin Tuweap'*, or "Rock Land," and sometimes the *Toom'pin wunear' Tuweap'*, or "Land of Standing Rock. . . ."

We continue our journey. In many places the walls, which rise from the water's edge, are overhanging on either side. The stream is still quiet, and we glide along through a strange, weird, grand region. The landscape everywhere, away from the river, is of rock—cliffs of rock, tables of rock, plateaus of rock, terraces of rock, crags of rock—ten thousand strangely carved forms; rocks everywhere, and no vegetation, no soil, no sand. In long, gentle curves the river winds about these rocks.

When thinking of these rocks one must not conceive of piles of boulders or heaps of fragments, but of a whole land of naked rock, with giant forms carved on it: cathedral-shaped buttes, towering hundreds or thousands of feet, cliffs that cannot be scaled, and canyon walls that shrink the river into insignificance, with vast, hollow domes and tall pinnacles and shafts set on the verge overhead; and all highly colored—buff, gray, red, brown, and chocolate—never lichened, never moss-covered, but bare, and often polished. . . .

Late in the afternoon the water becomes swift and our boats make great speed. An hour of this rapid running brings us to the junction of the Grand and Green, the foot of Stillwater Canyon, as we have named it. These streams unite in solemn depths, more than 1,200 feet below the general surface of the country. The walls of the lower end of Stillwater Canyon are very beautifully curved, as the river sweeps in its meandering course. The lower end of the canyon through which the Grand comes down is also regular, but much more direct, and we look up this stream and out into the country beyond and obtain glimpses of snow-clad peaks, the summits of a group of mountains known as the Sierra La Sal. Down the Colorado the canyon walls are much broken.

We row around into the Grand and camp on its northwest bank; and here we propose to stay several days, for the purpose of determining the latitude and longitude and the altitude of the walls. Much of the night is spent in making observations with the sextant. . . .

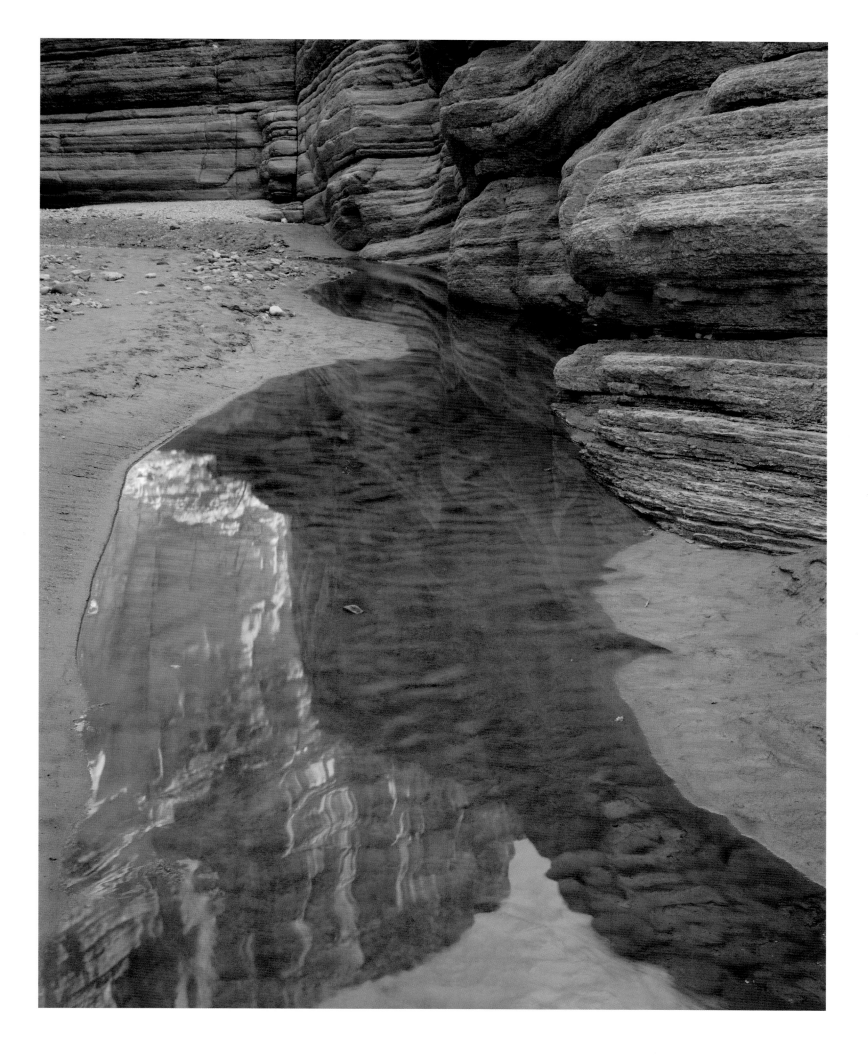

# Distant Uplands

*In the warmer seasons, the cool uplands of the central portion of the Colorado basin offer comforting refuge from the hot, stark lower elevations. For years after first seeing the exquisite engravings in Powell's account of his journey I wanted to visit the lovely forests of the Kaibab Plateau, immediately north of the Grand Canyon.*

*In May of 1985 I finally made it to the Kaibab. Unlike the south rim, the north rim is very hilly, although the hills are small enough to go unnoticed from the far rim. I was also surprised to find a few small limestone sinkhole lakes. As on the south rim, the shock of encountering the brink of the colossal gorge is overwhelming, but the forests alone make the trip worthwhile.*

*Another favorite upland is the vicinity of Cedar Breaks National Monument. The rim of Cedar Breaks, at over 10,000 feet, is on the western boundary of the Colorado's watershed. Magnificent aspen forests grace much of Utah's higher elevations, and in autumn are sometimes reminiscent of the peak beauty of New England woods. The turned leaves persist for only a few days. With each breeze comes a gentle rain of yellow or amber drifting quietly to the ground. At one place near Cedar Breaks, I chanced upon a horned toad, motionless, at over 9,000 feet. I picked him up to show my daughters, marveling at the brilliance of his markings and his surreal form, then carefully returned him to his spot. He was much lovelier than any I had seen before.*

*At over 8,000 feet, Bryce Canyon National Park also offers cool refuge during the warmer months, but unlike the other two places it stays open all year. Bryce is a part of the eastern edge of a plateau, not a canyon. Its fabulous spires have been carved by weathering and rain in a layer of fifty to sixty million-year-old lake deposits. These Pink Cliffs are the uppermost step in the "Grand Staircase," which rises to the north between the Grand Canyon and Bryce. Below and south of the Pink Cliffs are the Gray, White, Vermilion, Chocolate, or Belted, Cliffs, and finally the Kaibab Plateau. The strata are inclined upward at an angle toward the south, so the drop in altitude from north to south averages but a small fraction of the geologic drop through the layers. The oldest rock of the staircase, the Kaibab Limestone, is over 225 million years old. At the very bottom of the Grand Canyon, many layers below the Kaibab, is the ancient Vishnu Schist, 1,800 million years of age.*

*In mountainous western Colorado are the headwaters of the Colorado River itself, with the source of the Green to the north and that of the San Juan to the south. The basin of the Colorado extends northerly to a point in the Wind River range of Wyoming, which divides the three great American drainages: the Mississippi, the Columbia, and the Colorado. The tributaries of the Colorado extend south to where the Gila River drains much of southern Arizona and small parts of northern Mexico.*

*A lifetime might be insufficient to visit each interesting part of the Colorado basin— Canyon de Chelly, Waterpocket Fold, the Painted Desert, Arches, Canyonlands, Dinosaur, Saguaro, Mesa Verde, the Petrified Forest, Zion, Chaco Canyon, Shiprock, the Hopi Mesas. Each has an air of magic, and together they form a landscape of extraordinary beauty and magnificence: the basin of the Colorado River.*

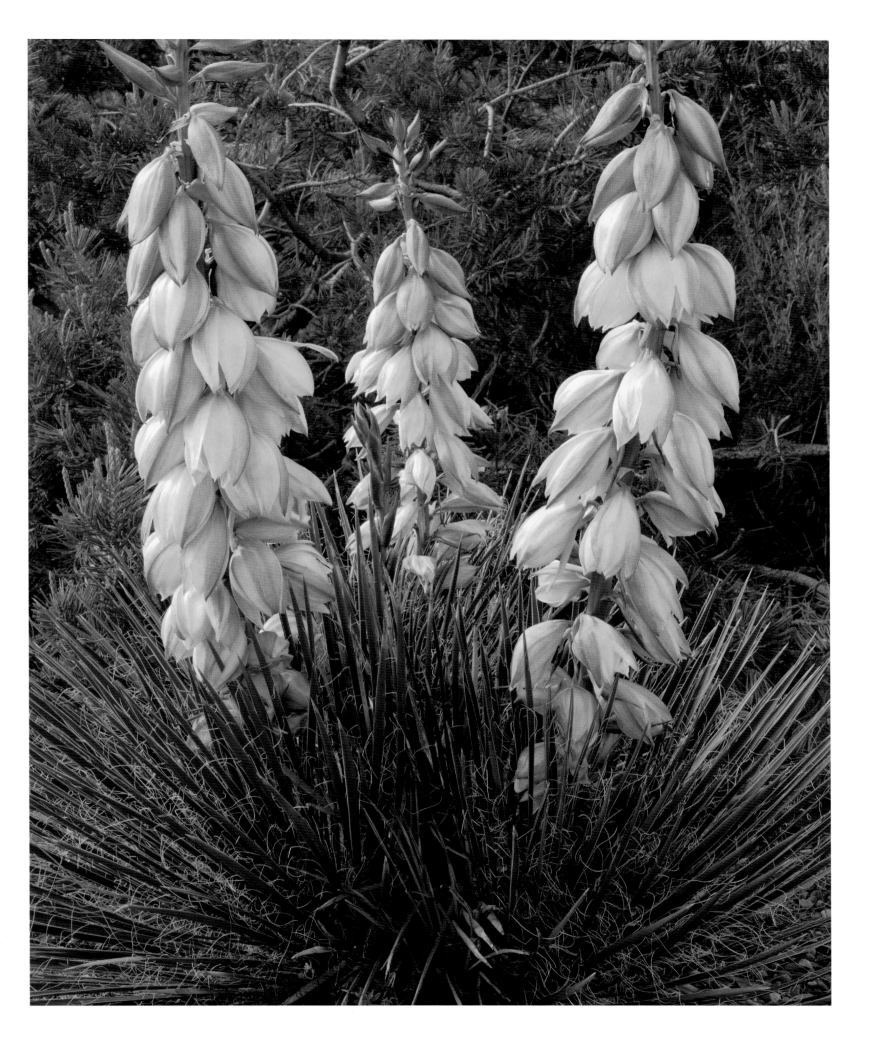

# FROM THE JUNCTION OF THE GRAND AND GREEN TO THE MOUTH OF THE LITTLE COLORADO

JULY 18  The day is spent in obtaining the time and spreading our rations, which we find are badly injured. The flour has been wet and dried so many times that it is all musty and full of hard lumps. We make a sieve of mosquito netting and run our flour through it, losing more than 200 pounds by the process. Our losses, by the wrecking of the "No Name," and by various mishaps since, together with the amount thrown away to-day, leave us little more than two months' supplies, and to make them last thus long we must be fortunate enough to lose no more.

We drag our boats on shore and turn them over to recalk and pitch them, and Sumner is engaged in repairing barometers. While we are here for a day or two, resting, we propose to put everything in the best shape for a vigorous campaign.

JULY 19  Bradley and I start this morning to climb the left wall below the junction. The way we have selected is up a gulch. Climbing for an hour over and among the rocks, we find ourselves in a vast amphitheater and our way cut off. We clamber around to the left for half an hour, until we find that we cannot go up in that direction. Then we try the rocks around to the right and discover a narrow shelf nearly half a mile long. In some places this is so wide that we pass along with ease; in others it is so narrow and sloping that we are compelled to lie down and crawl. We can look over the edge of the shelf, down 800 feet, and see the river rolling and plunging among the rocks. Looking up 500 feet to the brink of the cliff, it seems to blend with the sky. We continue along until we come to a point where the wall is again broken down. Up we climb. On the right there is a narrow, mural point of rocks, extending toward the river, 200 or 300 feet high and 600 or 800 feet long. We come back to where this sets in and find it cut off from the main wall by a great crevice. Into this we pass; and now a long, narrow rock is between us and the river. The rock itself is split longitudinally and transversely; and the rains on the surface above have run down through the crevices and gathered into channels below and then run off into the river. The crevices are usually narrow above and, by erosion of the streams, wider below, forming a network of caves, each cave having a narrow, winding skylight up through the rocks. We wander among these corridors for an hour or two, but find no place where the rocks are broken down so that we can climb up. At last we determine to attempt a passage by a crevice, and select one which we think is wide enough to admit of the passage of our bodies and yet narrow enough to climb out by pressing our hands and feet against the walls. So we climb as men would out of a well. Bradley climbs first; I hand him the barometer, then climb over his head and he hands me the barometer. So we pass each other alternately until we emerge from the fissure, out on the summit of the rock. And what a world of grandeur is spread before us! Below is the canyon through which the Colorado runs. We can trace its course for miles, and at points catch glimpses of the river. From the northwest comes the Green in a narrow winding gorge. From the northeast comes the Grand, through a canyon that seems bottomless from where we stand. Away to the west are lines of cliffs and ledges of rock—not such ledges as the reader may have seen where the quarryman splits his blocks, but ledges from which the gods might quarry mountains that, rolled out on the plain below, would stand a lofty range; and not such cliffs as the reader may have seen where the swallow builds its nest, but cliffs where the soaring eagle is lost to view ere he reaches the summit. Between us and the distant cliffs are the strangely carved and pinnacled rocks of the *Toom'pin wunear' Tuweap'*. On the summit of the opposite wall of the canyon are rock forms that we do not understand. Away to the east a group of eruptive mountains are seen—the Sierra La Sal, which we first saw two days ago through the canyon of the Grand. Their slopes are covered with pines, and deep gulches

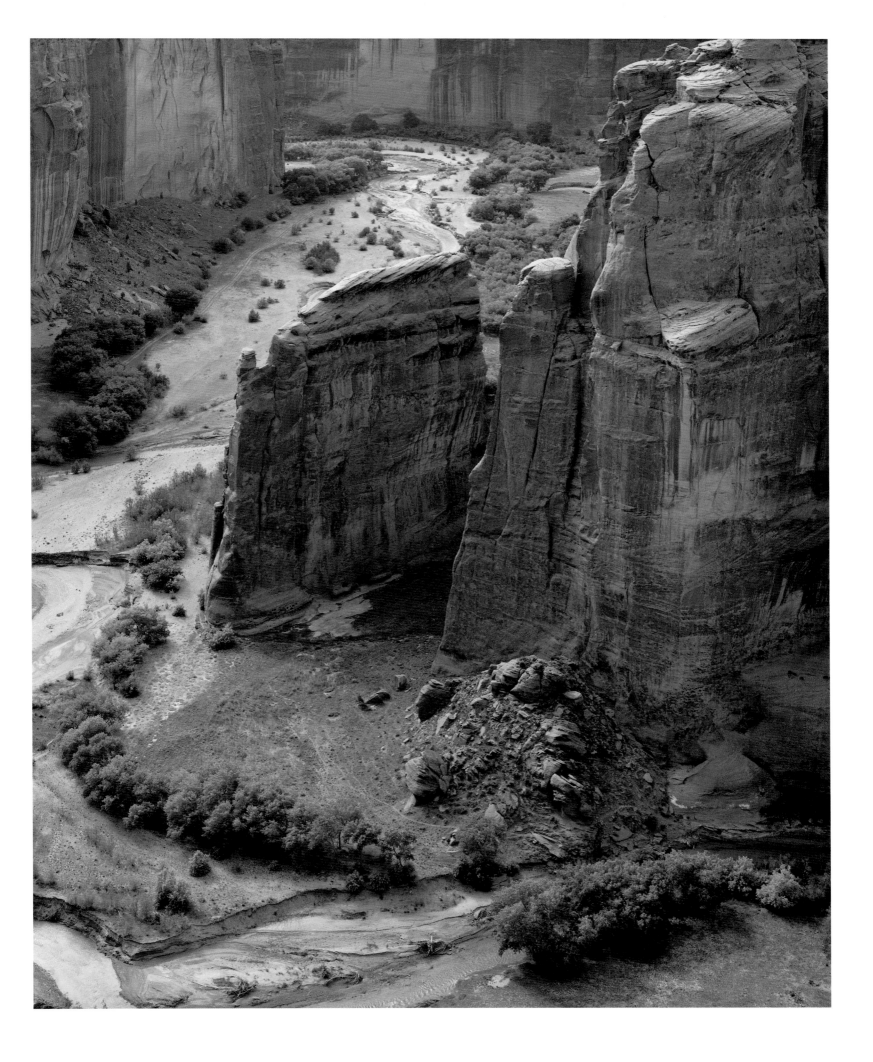

but may be we shall come to a fall in these canyons which we cannot pass, where the walls rise from the water's edge, so that we cannot land, and where the water is so swift that we cannot return. Such places have been found, except that the falls were not so great but that we could run them with safety. How will it be in the future? So they speculate over the serious probabilities in jesting mood.

JULY 24   We examine the rapids below. Large rocks have fallen from the walls—great, angular blocks, which have rolled down the talus and are strewn along the channel. We are compelled to make three portages in succession, the distance being less than three fourths of a mile, with a fall of 75 feet. Among these rocks, in chutes, whirlpools, and great waves, with rushing breakers and foam, the water finds its way, still tumbling down. We stop for the night only three fourths of a mile below the last camp. . . .

JULY 25   Still more rapids and falls to-day. In one, the "Emma Dean" is caught in a whirlpool and set spinning about, and it is with great difficulty we are able to get out of it with only the loss of an oar. At noon another is made; and on we go, running some of the rapids, letting down with lines past others, and making two short portages. We camp on the right bank, hungry and tired.

JULY 26   We run a short distance this morning and go into camp to make oars and repair boats and barometers. The walls of the canyon have been steadily increasing in altitude to this point, and now they are more than 2,000 feet high. In many places they are vertical from the water's edge; in others there is a talus between the river and the foot of the cliff; and they are often broken down by side canyons. It is probable that the river is nearly as low now as it is ever found. High-water mark can be observed 40, 50, 60, or 100 feet above its present stage. Sometimes logs and driftwood are seen wedged into the crevices overhead, where floods have carried them.

About ten o'clock, Powell, Bradley, Howland, Hall, and I start up a side canyon to the east. We soon come to pools of water; then to a brook, which is lost in the sands below; and passing up the brook, we see that the canyon narrows, the walls close in and are often overhanging, and at last we find ourselves in a vast amphitheater, with a pool of deep, clear, cold water on the bottom. At first our way seems cut off; but we soon discover a little shelf, along which we climb, and, passing beyond the pool, walk a hundred yards or more, turn to the right, and find ourselves in another dome-shaped amphitheater. There is a winding cleft at the top, reaching out to the country above, nearly 2,000 feet overhead. The rounded, basin-shaped bottom is filled with water to the foot of the walls. There is no shelf by which we can pass around the foot. If we swim across we meet with a face of rock hundreds of feet high, over which a little rill glides, and it will be impossible to climb. So we can go no farther up this canyon. Then we turn back and examine the walls on either side carefully, to discover, if possible, some way of climbing out. In this search every man takes his own course, and we are scattered. I almost abandon the idea of getting out and am engaged in searching for fossils, when I discover, on the north, a broken place up which it may be possible to climb. The way for a distance is up a slide of rocks; then up an irregular amphitheater, on points that form steps and give handhold; and then I reach a little shelf, along which I walk, and discover a vertical fissure parallel to the face of the wall and reaching to a higher shelf. This fissure is narrow and I try to climb up to the bench, which is about 40 feet overhead. I have a barometer on my back, which rather impedes my climbing. The walls of the fissure are of smooth limestone, offering neither foothold nor handhold. So I support myself by pressing my back against one wall and my knees against the other, and in this way lift my body, in a shuffling manner, a few inches at a time, until I have made perhaps 25 feet of the distance, when the crevice widens a little and I cannot press my knees against the rock in front with sufficient power to give me support in lifting my body; so I try to go back. This I cannot do without falling. So I struggle along sidewise farther into the crevice, where it narrows. But by this time my muscles are exhausted, and I cannot climb longer; so I move still a little farther into the crevice, where it is so narrow and wedging that I can lie in it, and there I rest. Five or ten minutes of this relief, and up once more I go, and reach the bench above. On this I can walk for a quarter of a mile, till I come to a place where the wall is again broken down, so I can climb up still farther; and in an hour I reach the summit. I hang

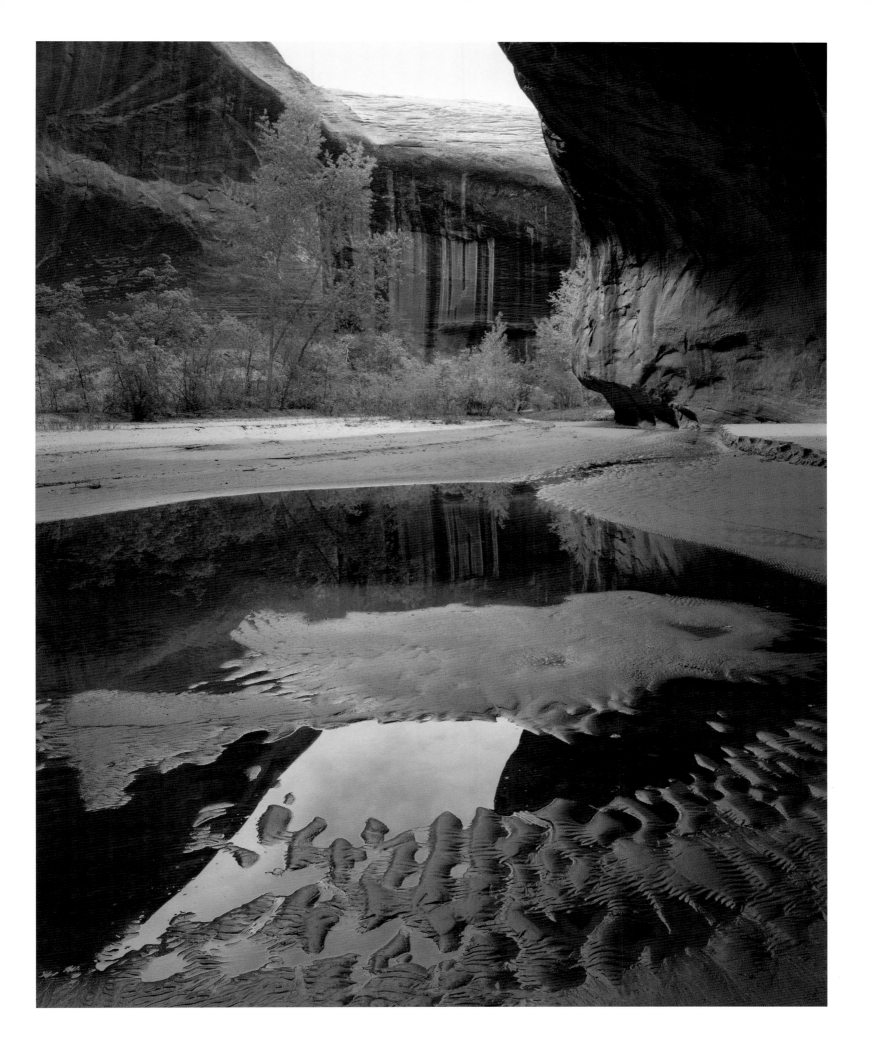

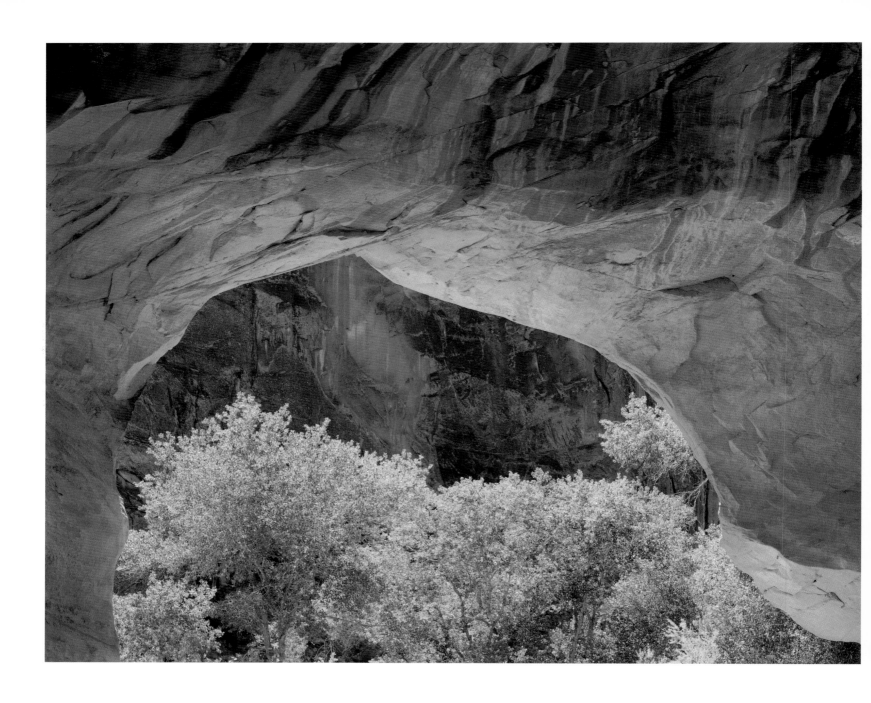

up my barometer to give it a few minutes' time to settle, and occupy myself in collecting resin from the piñon pines, which are found in great abundance. One of the principal objects in making this climb was to get this resin for the purpose of smearing our boats; but I have with me no means of carrying it down. The day is very hot and my coat was left in camp, so I have no linings to tear out. Then it occurs to me to cut off the sleeve of my shirt and tie it up at one end, and in this little sack I collect about a gallon of pitch. After taking observations for altitude, I wander back on the rock for an hour or two, when suddenly I notice that a storm is coming from the south. I seek a shelter in the rocks; but when the storm bursts, it comes down as a flood from the heavens,—not with gentle drops at first, slowly increasing in quantity, but as if suddenly poured out. I am thoroughly drenched and almost washed away. It lasts not more than half an hour, when the clouds sweep by to the north and I have sunshine again.

In the meantime I have discovered a better way of getting down, and start for camp, making the greatest haste possible. On reaching the bottom of the side canyon, I find a thousand streams rolling down the cliffs on every side, carrying with them red sand; and these all unite in the canyon below in one great stream of red mud.

Traveling as fast as I can run, I soon reach the foot of the stream, for the rain did not reach the lower end of the canyon and the water is running down a dry bed of sand; and although it comes in waves several feet high and 15 or 20 feet in width, the sands soak it up and it is lost. But wave follows wave and rolls along and is swallowed up; and still the floods come on from above. I find that I can travel faster than the stream; so I hasten to camp and tell the men there is a river coming down the canyon. We carry our camp equipage hastily from the bank to where we think it will be above the water. Then we stand by and see the river roll on to join the Colorado. . . .

JULY 27    We have more rapids and falls until noon; then we come to a narrow place in the canyon, with vertical walls for several hundred feet, above which are steep steps and sloping rocks back to the summits. The river is very narrow, and we make our way with great care and much anxiety, hugging the wall on the left and carefully examining the way before us.

Late in the afternoon we pass to the left around a sharp point, which is somewhat broken down near the foot, and discover a flock of mountain sheep on the rocks more than a hundred feet above us. We land quickly in a cove out of sight, and away go all the hunters with their guns, for the sheep have not discovered us. Soon we hear firing, and those of us who have remained in the boats climb up to see what success the hunters have had. One sheep has been killed, and two of the men are still pursuing them. In a few minutes we hear firing again, and the next moment down come the flock clattering over the rocks within 20 yards of us. One of the hunters seizes his gun and brings a second sheep down, and the next minute the remainder of the flock is lost behind the rocks. We all give chase; but it is impossible to follow their tracks over the naked rock, and we see them no more. Where they went out of this rock-walled canyon is a mystery, for we can see no way of escape. . . .

We lash our prizes to the deck of one of the boats and go on for a short distance; but fresh meat is too tempting for us, and we stop early to have a feast. And a feast it is! Two fine young sheep! We care not for bread or beans or dried apples to-night; coffee and mutton are all we ask.

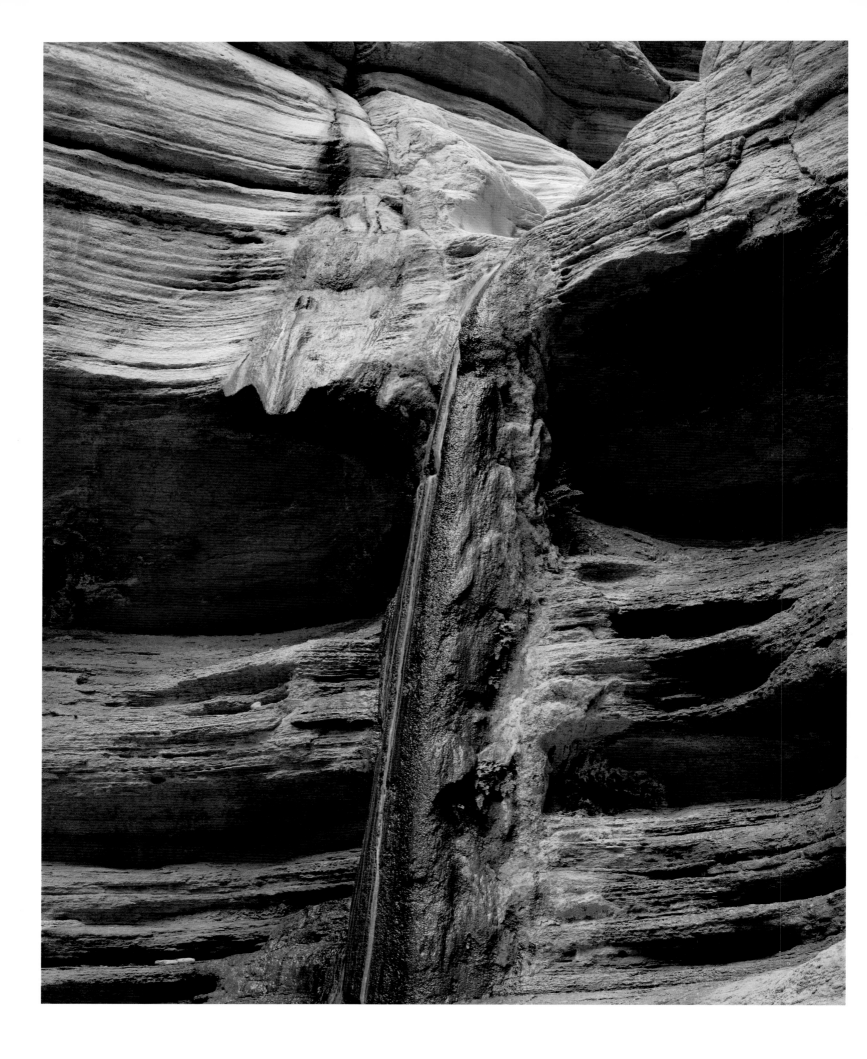

JULY 28   We make two portages this morning, one of them very long. During the afternoon we run a chute more than half a mile in length, narrow and rapid. This chute has a floor of marble; the rocks dip in the direction in which we are going, and the fall of the stream conforms to the inclination of the beds; so we float on water that is gliding down an inclined plane. At the foot of the chute the river turns sharply to the right and the water rolls up against a rock which from above seems to stand directly athwart its course. As we approach it we pull with all our power to the right, but it seems impossible to avoid being carried headlong against the cliff; we are carried up high on the waves—but not against the rock, for the rebounding water strikes us and we are beaten back and pass on with safety, except that we get a good drenching.

After this the walls suddenly close in, so that the canyon is narrower than we have ever known it. The water fills it from wall to wall, giving us no landing-place at the foot of the cliff; the river is very swift and the canyon very tortuous, so that we can see but a few hundred yards ahead; the walls tower over us, often overhanging so as almost to shut out the light. I stand on deck, watching with intense anxiety, lest this may lead us into some danger; but we glide along, with no obstruction, no falls, no rocks, and in a mile and a half emerge from the narrow gorge into a more open and broken portion of the canyon. Now that it is past, it seems a very simple thing indeed to run through such a place, but the fear of what might be ahead made a deep impression on us.

At three o'clock we arrive at the foot of Cataract Canyon. Here a long canyon valley comes down from the east, and the river turns sharply to the west in a continuation of the line of the lateral valley. In the bend on the right vast numbers of crags and pinnacles and tower-shaped rocks are seen. We call it Mille Crag Bend.

And now we wheel into another canyon, on swift water unobstructed by rocks. This new canyon is very narrow and very straight, with walls vertical below and terraced above. Where we enter it the brink of the cliff is 1,300 feet above the water, but the rocks dip to the west, and as the course of the canyon is in that direction the walls are seen slowly to decrease in altitude. Floating down this narrow channel and looking out through the canyon crevice away in the distance, the river is seen to turn again to the left, and beyond this point, away many miles, a great mountain is seen. Still floating down, we see other mountains, now on the right, now on the left, until a great mountain range is unfolded to view. We name this Narrow Canyon, and it terminates at the bend of the river below.

As we go down to this point we discover the mouth of a stream which enters from the right. Into this our little boat is turned. The water is exceedingly muddy and has an unpleasant odor. One of the men in the boat following, seeing what we have done, shouts to Dunn and asks whether it is a trout stream. Dunn replies, much disgusted, that it is "a dirty devil," and by this name the river is to be known hereafter.

Some of us go out for half a mile and climb a butte to the north. The course of the Dirty Devil River can be traced for many miles. It comes down through a very narrow canyon, and beyond it, to the southwest, there is a long line of cliffs, with a broad terrace, or bench, between it and the brink of the canyon, and beyond these cliffs is situated the range of mountains seen as we came down Narrow Canyon. Looking up the Colorado, the chasm through which it runs can be seen, but we cannot see down to its waters. The whole country is a region of naked rock of many colors, with cliffs and buttes about us and towering mountains in the distance.

JULY 29   We enter a canyon to-day, with low, red walls. A short distance below its head we discover the ruins of an old building on the left wall. There is a narrow plain between the river and the wall just here, and on the brink of a rock 200 feet high stands this old house. Its walls are of stone, laid in mortar with much regularity. It was probably built three stories high; the lower story is yet almost intact; the second is much broken down, and scarcely anything is left of the third. Great quantities of flint chips are found on the rocks near by, and many arrowheads, some perfect, others broken; and fragments of pottery are strewn about in great profusion. On the face of the cliff, under the building and along down the river for 200 or 300 yards, there are many etchings. Two hours are given to the examination of these interesting ruins; then we run down fifteen miles farther, and discover another group. The principal

building was situated on the summit of the hill. A part of the walls are standing, to the height of eight or ten feet, and the mortar yet remains in some places. The house was in the shape of an L, with five rooms on the ground floor,—one in the angle and two in each extension. In the space in the angle there is a deep excavation. From what we know of the people in the Province of Tusayan, who are, doubtless, of the same race as the former inhabitants of these ruins, we conclude that this was a *kiva,* or underground chamber in which their religious ceremonies were performed.

We leave these ruins and run down two or three miles and go into camp about mid-afternoon. And now I climb the wall and go out into the back country for a walk. . . .

Just before sundown I attempt to climb a rounded eminence, from which I hope to obtain a good outlook on the surrounding country. It is formed of smooth mounds, piled one above another. Up these I climb, winding here and there to find a practicable way, until near the summit they become too steep for me to proceed. I search about a few minutes for an easier way, when I am surprised at finding a stairway, evidently cut in the rock by hands. At one place, where there is a vertical wall of 10 or 12 feet, I find an old, rickety ladder. It may be that this was a watchtower of that ancient people whose homes we have found in ruins. On many of the tributaries of the Colorado, I have heretofore examined their deserted dwellings. Those that show evidences of being built during the latter part of their occupation of the country are usually placed on the most inaccessible cliffs. Sometimes the mouths of caves have been walled across, and there are many other evidences to show their anxiety to secure defensible positions. Probably the nomadic tribes were sweeping down upon them and they resorted to these cliffs and canyons for safety. It is not unreasonable to suppose that this orange mound was used as a watchtower. Here I stand, where these now lost people stood centuries ago, and look over this strange country, gazing off to great mountains in the northwest which are slowly disappearing under cover of the night; and then I return to camp. It is no easy task to find my way down the wall in the darkness, and I clamber about until it is nearly midnight when camp is reached.

JULY 30   We make good progress to-day, as the water, though smooth, is swift. Sometimes the canyon walls are vertical to the top; sometimes they are vertical below and have a mound-covered slope above; in other places the slope, with its mounds, comes down to the water's edge.

Still proceeding on our way, we find that the orange sandstone is cut in two by a group of firm, calcareous strata, and the lower bed is underlaid by soft, gypsiferous shales. Sometimes the upper homogeneous bed is a smooth, vertical wall, but usually it is carved with mounds, with gently meandering valley lines. The lower bed, yielding to gravity, as the softer shales below work out into the river, breaks into angular surfaces, often having a columnar appearance. One could almost imagine that the walls had been carved with a purpose, to represent giant architectural forms. In the deep recesses of the walls we find springs, with mosses and ferns on the moistened sandstone.

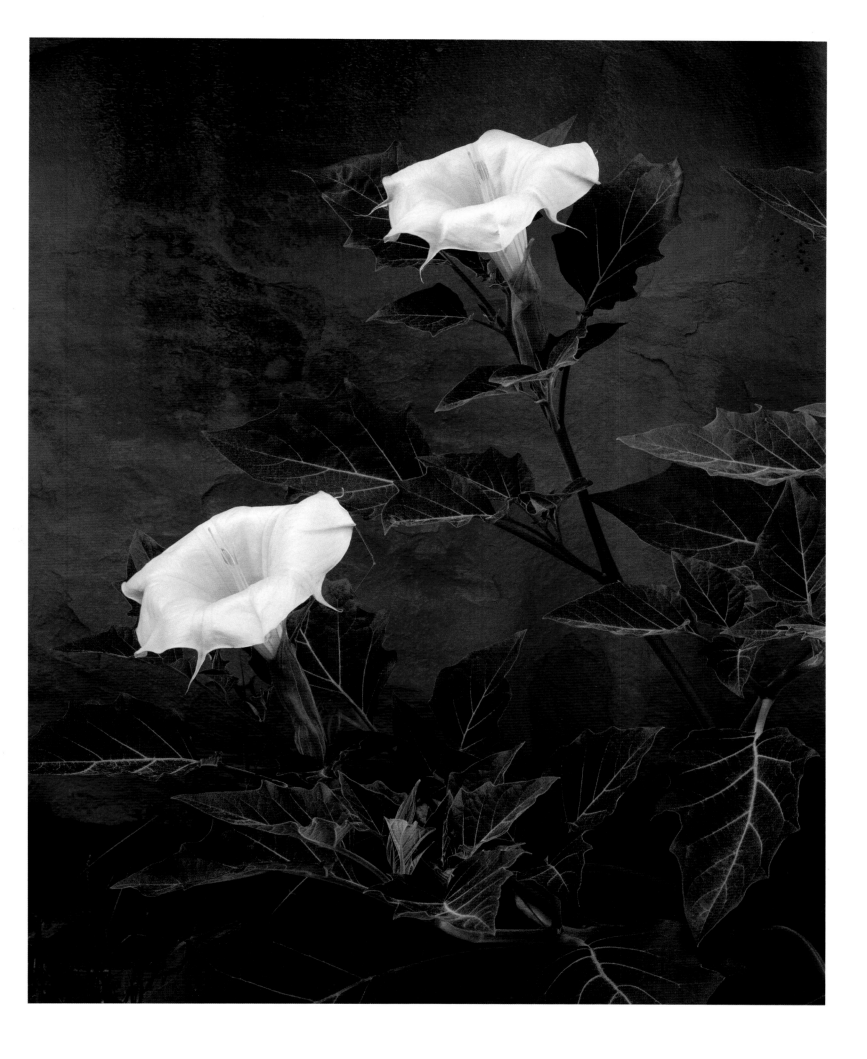

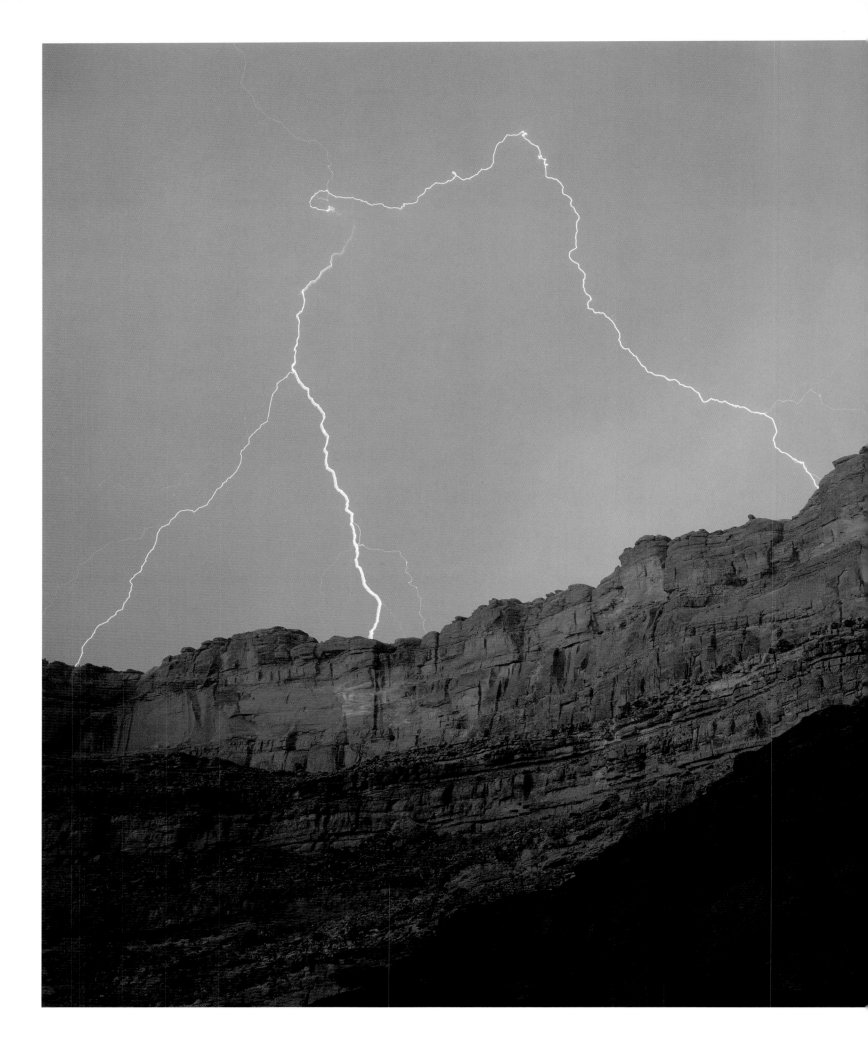

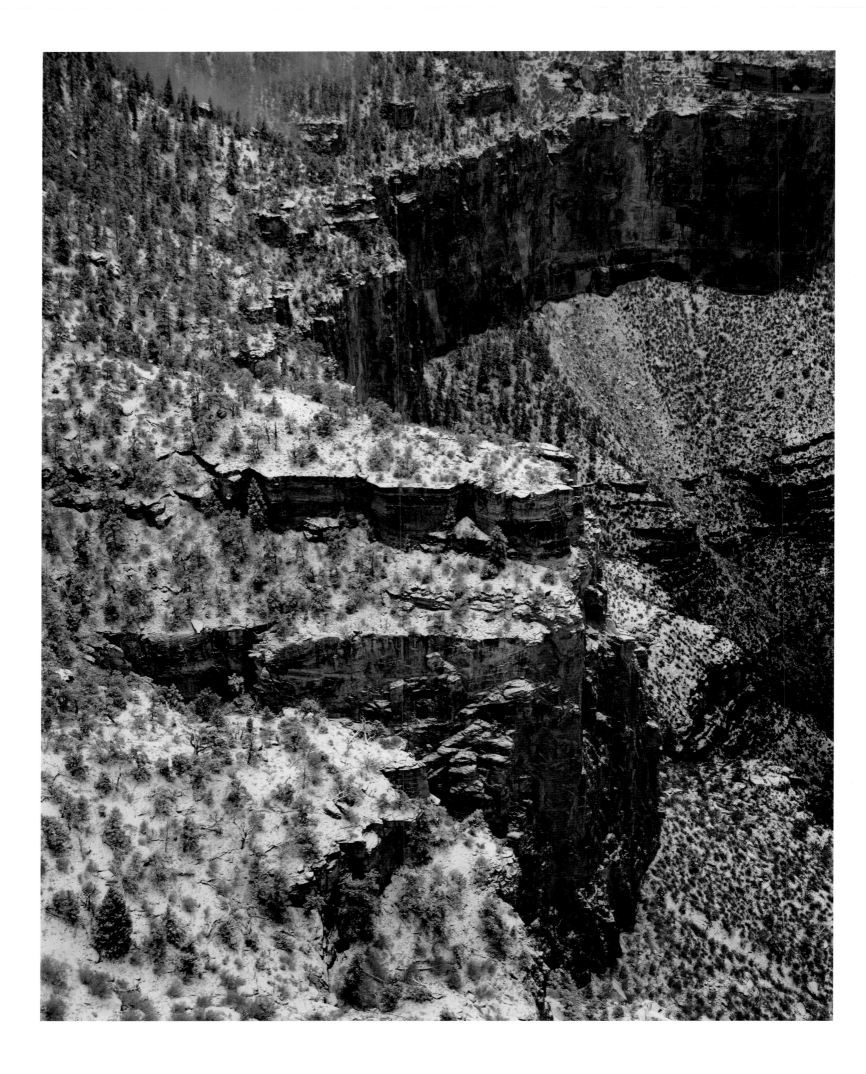

AUGUST 3   Start early this morning. The features of
this canyon are greatly diversified. Still vertical walls at times.
These are usually found to stand above great curves. The river,
sweeping around these bends, undermines the cliffs in places.
Sometimes the rocks are overhanging; in other curves, curious,
narrow glens are found. Through these we climb, by a rough
stairway, perhaps several hundred feet, to where a spring bursts
out from under an overhanging cliff, and where cottonwoods
and willows stand, while along the curves of the brooklet oaks
grow, and other rich vegetation is seen, in marked contrast to
the general appearance of naked rock. We call these Oak Glens.

Other wonderful features are the many side canyons or
gorges that we pass. Sometimes we stop to explore these for a
short distance. In some places their walls are much nearer each
other above than below, so that they look somewhat like caves
or chambers in the rocks. Usually, in going up such a gorge, we
find beautiful vegetation; but our way is often cut off by deep
basins, or "potholes," as they are called.

On the walls, and back many miles into the country, num-
bers of monument-shaped buttes are observed. So we have a
curious *ensemble* of wonderful features—carved walls, royal
arches, glens, alcove gulches, mounds, and monuments. From
which of these features shall we select a name. We decide to
call it Glen Canyon.

Past these towering monuments, past these mounded bil-
lows of orange sandstone, past these oak-set glens, past these
fern-decked alcoves, past these mural curves, we glide hour
after hour, stopping now and then, as our attention is arrested
by some new wonder, until we reach a point which is historic.

In the year 1776, Father Escalante, a Spanish priest, made
an expedition from Santa Fé to the northwest, crossing the
Grand and Green, and then passing down along the Wasatch
Mountains and the southern plateaus until he reached the

Rio Virgen. His intention was to cross to the Mission of Monterey; but, from information received from the Indians he decided that the route was impracticable. Not wishing to return to Santa Fé over the circuitous route by which he had just traveled, he attempted to go by one more direct, which led him across the Colorado at a point known as El Vado de los Padres. From the description which we have read, we are enabled to determine the place. A little stream comes down through a very narrow side canyon from the west. It was down this that he came, and our boats are lying at the point where the ford crosses. A well-beaten Indian trail is seen here yet. Between the cliff and the river there is a little meadow. The ashes of many camp fires are seen, and the bones of numbers of cattle are bleaching on the grass. For several years the Navajos have raided on the Mormons that dwell in the valleys to the west, and they doubtless cross frequently at this ford with their stolen cattle.

AUGUST 4  To-day the walls grow higher and the canyon much narrower. Monuments are still seen on either side; beautiful glens and alcoves and gorges and side canyons are yet found. After dinner we find the river making a sudden turn to the northwest and the whole character of the canyon changed. The walls are many hundreds of feet higher, and the rocks are chiefly variegated shales of beautiful colors—creamy orange above, then bright vermilion, and below, purple and chocolate beds, with green and yellow sands. We run four miles through this, in a direction a little to the west of north, wheel again to the west, and pass into a portion of the canyon where the characteristics are more like those above the bend. At night we stop at the mouth of a creek coming in from the right, and suppose it to be the Paria, which was described to me last year by a Mormon missionary. Here the canyon terminates abruptly in a line of cliffs, which stretches from either side across the river.

AUGUST 5  With some feeling of anxiety we enter a new canyon this morning. We have learned to observe closely the texture of the rock. In softer strata we have a quiet river, in harder we find rapids and falls. Below us are the limestones and hard sandstones which we found in Cataract Canyon. This bodes toil and danger. Besides the texture of the rocks, there is another condition which affects the character of the channel, as we have found by experience. Where the strata are horizontal the river is often quiet, and, even though it may be very swift in places, no great obstacles are found. Where the rocks incline in the direction traveled, the river usually sweeps with great velocity, but still has few rapids and falls. But where the rocks dip up stream and the river cuts obliquely across the upturned formations, harder strata above and softer below, we have rapids and falls. Into hard rocks and into rocks dipping up stream we pass this morning and start on a long, rocky, mad rapid. On the left there is a vertical rock, and down by this cliff and around to the left we glide, tossed just enough by the waves to appreciate the rate at which we are traveling.

The canyon is narrow, with vertical walls, which gradually grow higher. More rapids and falls are found. We come to one with a drop of sixteen feet, around which we make a portage, and then stop for dinner. Then a run of two miles, and another portage, long and difficult; then we camp for the night on a bank of sand.

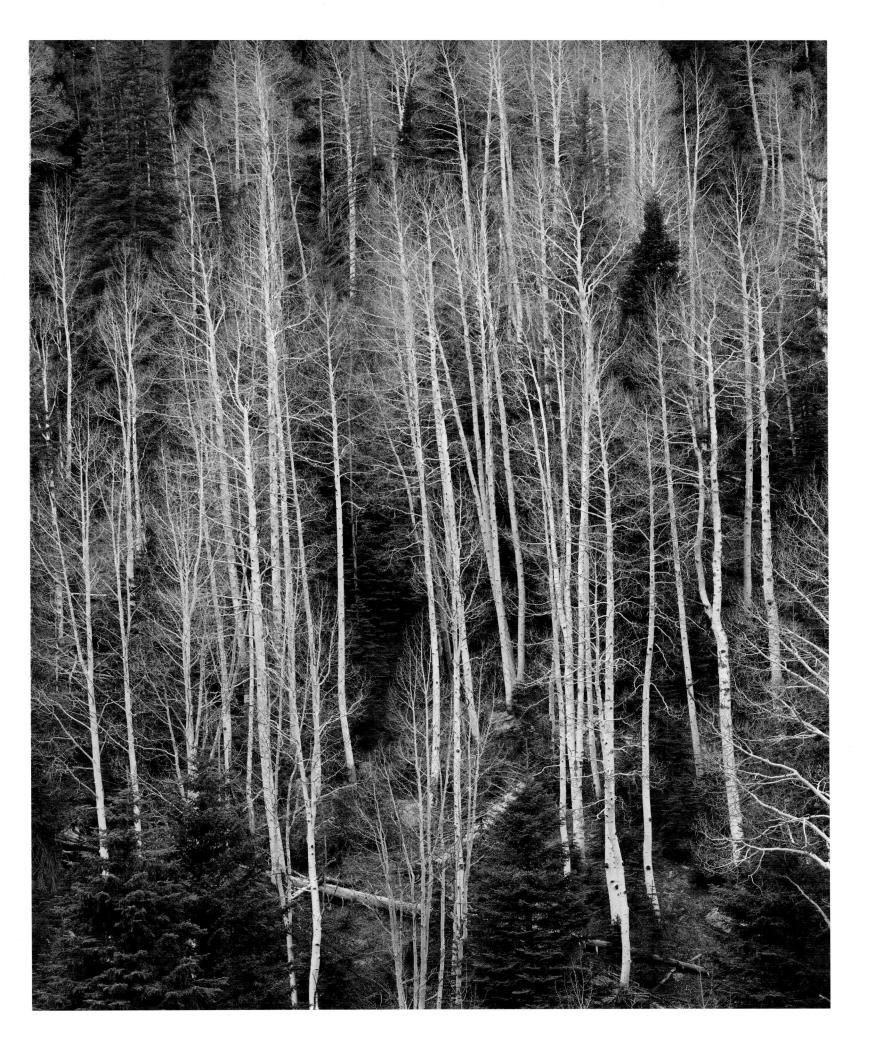

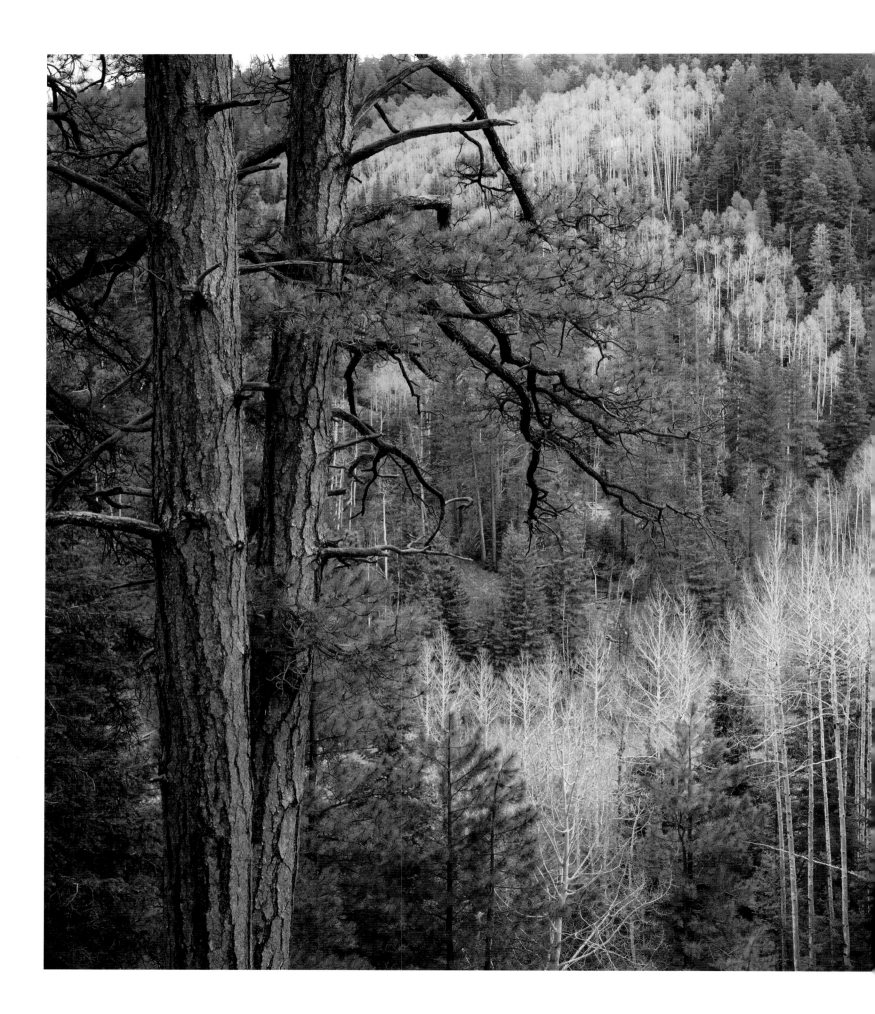

AUGUST 7   The almanac tells us that we are to have an eclipse of the sun to-day; so Captain Powell and myself start early, taking our instruments with us for the purpose of making observations on the eclipse to determine our longitude. Arriving at the summit, after four hours' hard climbing to attain 2,300 feet in height, we hurriedly build a platform of rocks on which to place our instruments, and quietly wait for the eclipse; but clouds come on and rain falls, and sun and moon are obscured.

Much disappointed, we start on our return to camp, but it is late and the clouds make the night very dark. We feel our way down among the rocks with great care for two or three hours, making slow progress indeed. At last we lose our way and dare proceed no farther. The rain comes down in torrents and we can find no shelter. We can neither climb up nor go down, and in the darkness dare not move about; so we sit and "weather out" the night.

AUGUST 8   Daylight comes after a long, oh, how long! a night, and we soon reach camp. After breakfast we start again, and make two portages during the forenoon.

The limestone of this canyon is often polished, and makes a beautiful marble. Sometimes the rocks are of many colors— white, gray, pink, and purple, with saffron tints. It is with very great labor that we make progress, meeting with many obstructions, running rapids, letting down our boats with lines from rock to rock, and sometimes carrying boats and cargoes around bad places. We camp at night, just after a hard portage, under an overhanging wall, glad to find shelter from the rain. We have to search for some time to find a few sticks of driftwood, just sufficient to boil a cup of coffee.

The water sweeps rapidly in this elbow of river, and has cut its way under the rock, excavating a vast half-circular chamber, which, if utilized for a theater, would give sitting to 50,000 people. Objection might be raised against it, however, for at high water the floor is covered with a raging flood.

AUGUST 9   And now the scenery is on a grand scale. The walls of the canyon, 2,500 feet high, are of marble, of many beautiful colors, often polished below by the waves, and sometimes far up the sides, where showers have washed the sands over the cliffs. At one place I have a walk for more than a mile on a marble pavement, all polished and fretted with strange devices and embossed in a thousand fantastic patterns. Through a cleft in the wall the sun shines on this pavement and it gleams in iridescent beauty. . . .

Riding down a short distance, a beautiful view is presented. The river turns sharply to the east and seems inclosed by a wall

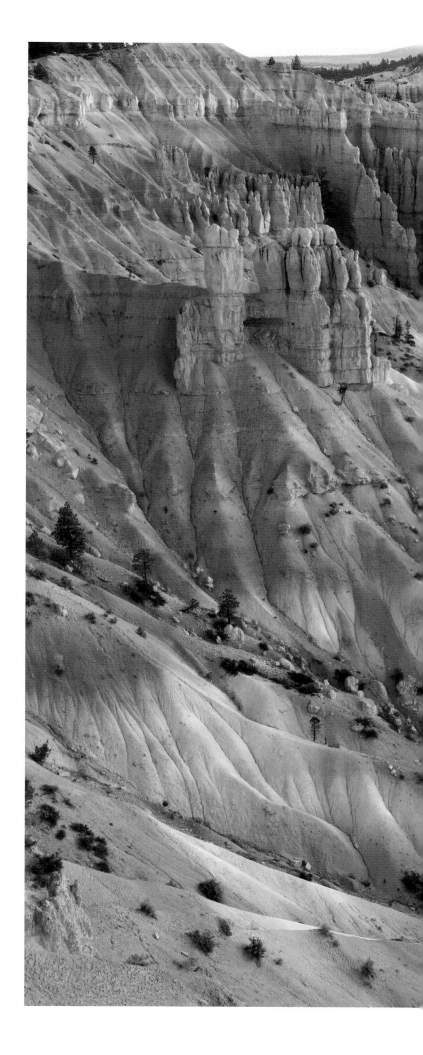

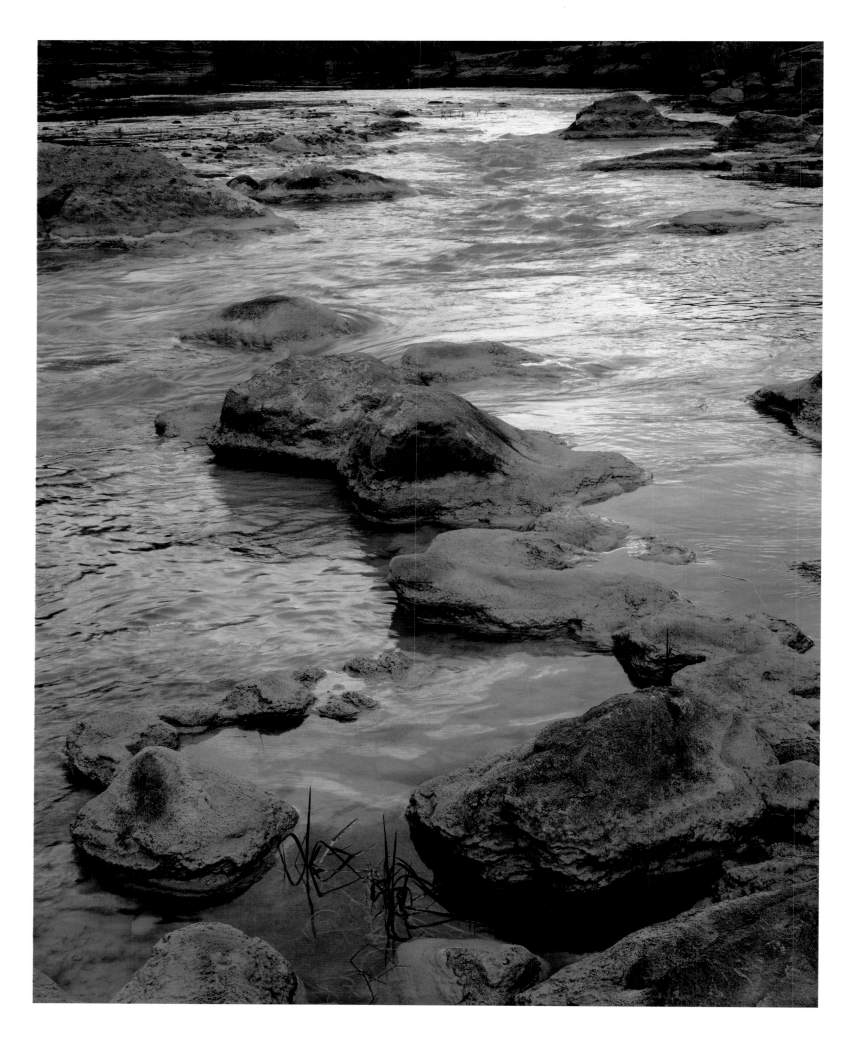

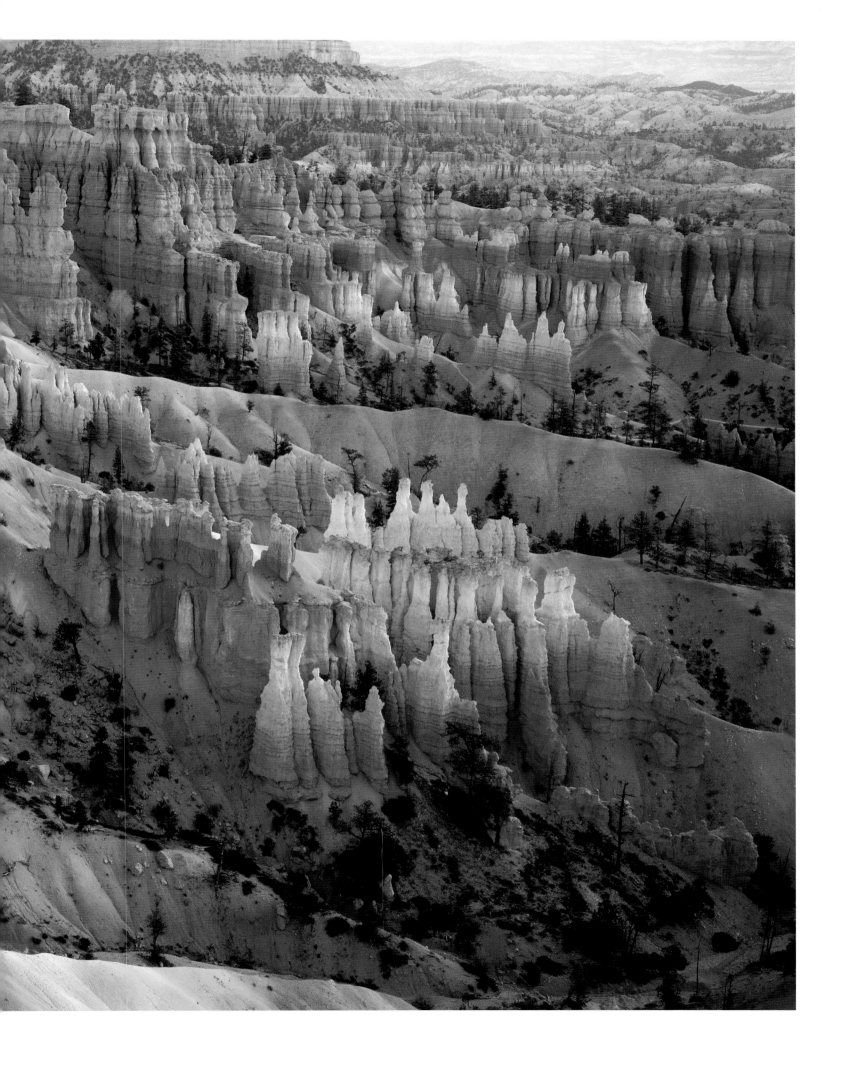

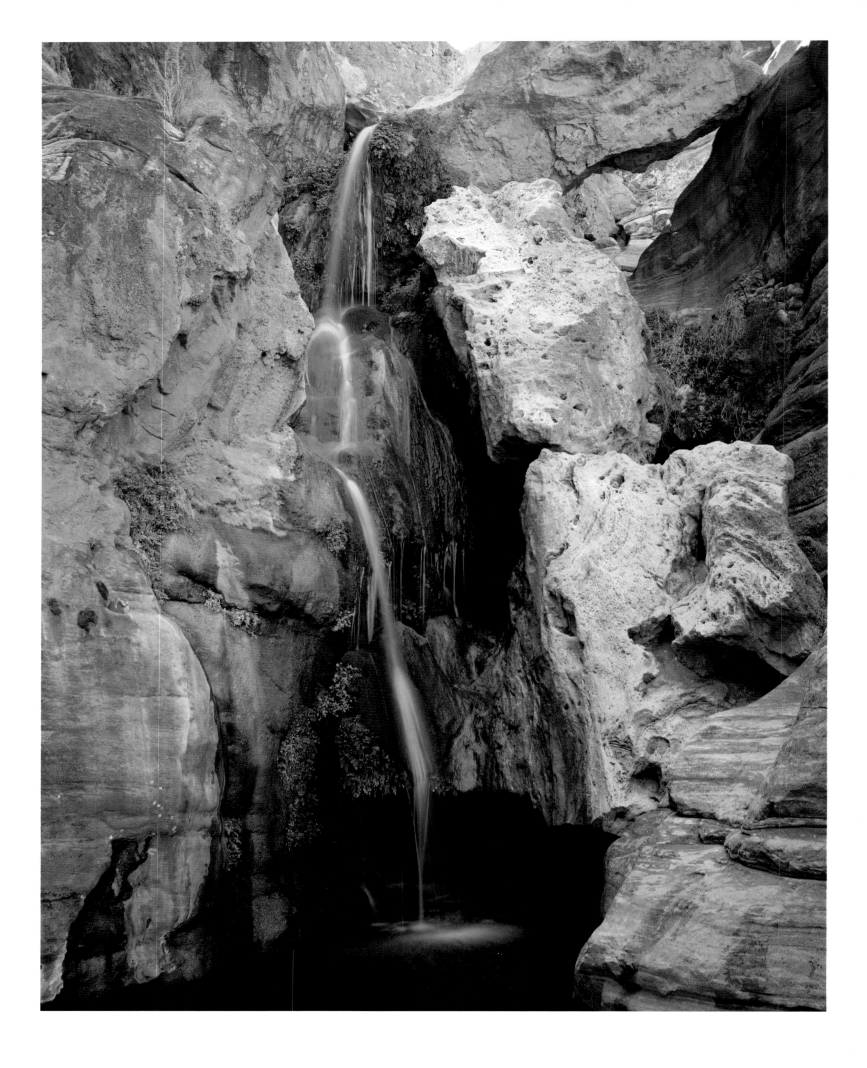

set with a million brilliant gems. What can it mean? Every eye is engaged, every one wonders. On coming nearer we find fountains bursting from the rock high overhead, and the spray in the sunshine forms the gems which bedeck the wall. The rocks below the fountain are covered with mosses and ferns and many beautiful flowering plants. We name it Vasey's Paradise, in honor of the botanist who traveled with us last year.

We pass many side canyons to-day that are dark, gloomy passages back into the heart of the rocks that form the plateau through which this canyon is cut. It rains again this afternoon. Scarcely do the first drops fall when little rills run down the walls. As the storm comes on, the little rills increase in size, until great streams are formed. Although the walls of the canyon are chiefly limestone, the adjacent country is of red sandstone; and now the waters, loaded with these sands, come down in rivers of bright red mud, leaping over the walls in innumerable cascades. It is plain now how these walls are polished in many places.

At last the storm ceases and we go on. We have cut through the sandstones and limestones met in the upper part of the canyon, and through one great bed of marble a thousand feet in thickness. In this, great numbers of caves are hollowed out, and carvings are seen which suggest architectural forms, though on a scale so grand that architectural terms belittle them. As this great bed forms a distinctive feature of the canyon, we call it Marble Canyon. . . .

The river is now quiet; the canyon wider. Above, when the river is at its flood, the waters gorge up, so that the difference between high and low water mark is often 50 or even 70 feet, but here high-water mark is not more than 20 feet above the present stage of the river. Sometimes there is a narrow flood plain between the water and the wall. Here we first discover mesquite shrubs,—small trees with finely divided leaves and pods, somewhat like the locust.

AUGUST 10   Walls still higher; water swift again. We pass several broad, ragged canyons on our right, and up through these we catch glimpses of a forest-clad plateau, miles away to the west.

At two o'clock we reach the mouth of the Colorado Chiquito. This stream enters through a canyon on a scale quite as grand as that of the Colorado itself. It is a very small river and exceedingly muddy and saline. I walk up the stream three or four miles this afternoon, crossing and recrossing where I can easily wade it. Then I climb several hundred feet at one place, and can see for several miles up the chasm through which the river runs. On my way back I kill two rattlesnakes, and find on my arrival that another has been killed just at camp.

AUGUST 11   We remain at this point to-day for the purpose of determining the latitude and longitude, measuring the height of the walls, drying our rations, and repairing our boats. . . .

We find . . . that the walls are about 3,000 feet high—more than half a mile—an altitude difficult to appreciate from a mere statement of feet. The slope by which the ascent is made is not such a slope as is usually found in climbing a mountain, but one much more abrupt—often vertical for many hundreds of feet,—so that the impression is given that we are at great depths, and we look up to see but a little patch of sky. . . .

Our camp is below the Colorado Chiquito and on the eastern side of the canyon.

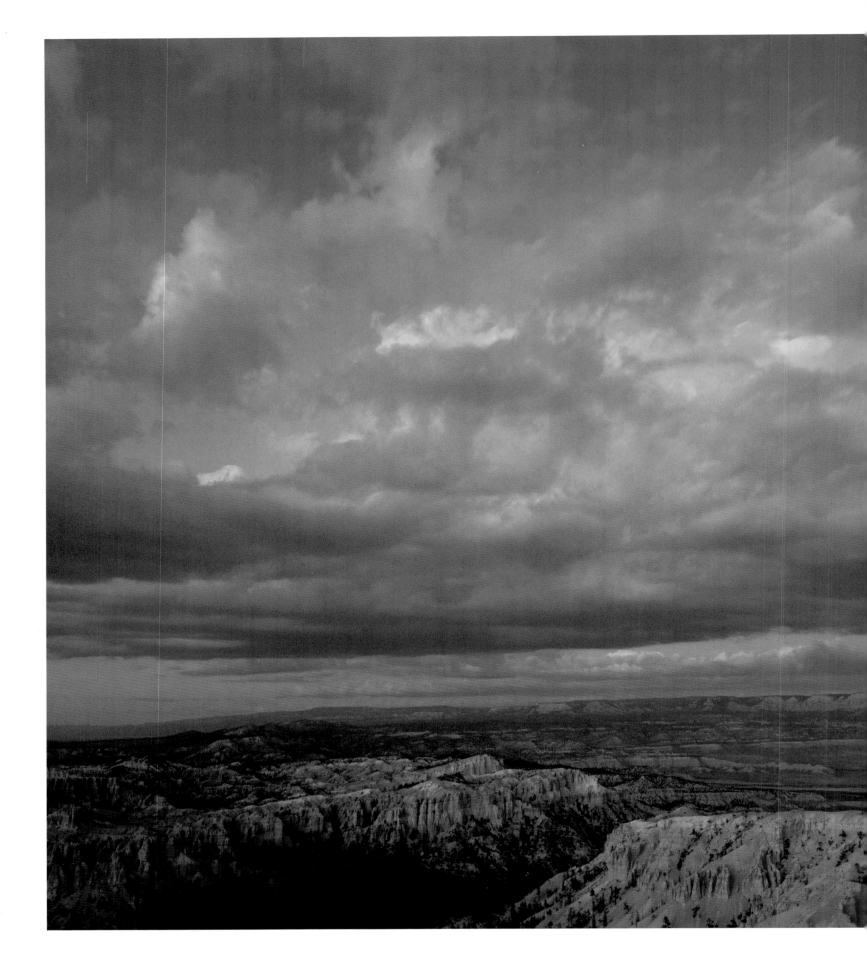

## Float the Escalante

*The Escalante is a canyon for backpackers and a few undernourished cows, not a canyon for rafters. The river is simply too small to fit a raft onto. But for about a week, possibly two or three in wetter-than-average years, the spring snowmelt puts enough water into the channel to float one-person inflatable kayaks.*

*For about fifteen years, my friends Steve and Janet Andersen and I had been planning to make the trip, and the time finally arrived in the spring of 1994. It hadn't been a wet winter, but Janet had to be in Las Vegas for a conference, and we had seen some boats that were well suited to the unique requirements of this river. As the window of opportunity approached, reports from the local rangers indicated that we were right on target to hit the peak snowmelt.*

*The Escalante is in the middle of the largest blank spot on the map of the lower forty-eight states. The put-in is at Calf Creek, where Highway 12 is reduced to a single lane crossing a tiny bridge over the river. The other end of the run is "Lake" Powell itself, 70 or 80 miles downriver, where one must rendezvous with obliging friends who have rented a boat at Bullfrog Marina, another 60 miles away across the reservoir. Making the rendezvous is critical, as the farther you get from the put-in, the more difficult it becomes to get out of the canyon. If our boats or one of us were to become disabled during the trip, we would be forced to hike up- or downstream to the nearest point where egress from the canyon is possible, then travel many miles cross-country to reach the end of a four-wheel-only dirt road leading to another dirt road, itself little traveled, leading 30 to 60 miles into town! Between two and three trips each would be required to retrieve all the gear—in short, an outcome to be avoided at all costs.*

*The situation demanded not only great care, but the most extreme weight-saving measures. Just adequate food and water, minimal clothes for warmth, the tiniest tent, the lightest bags—but the camera gear had to come, and it had to be waterproof. Jackets were deemed unacceptable weight, and we limited ourselves instead to warm hats, thermal underwear and raingear. Some years the temperature surpasses 100 degrees in late April. But not in 1994.*

*When we arrived at the river, at what was supposed to be the optimum time to catch the spring "flood," what we found was barely a small creek. I estimated the total flow to be roughly two or three cubic feet per second—about five feet wide and a few inches deep! A typical flow for runs we used to make on the Stanislaus was around 2,000 cubic feet per second. The Tatshenshini-Alsek in flood a few years ago had 600,000 cubic feet per second, and the lower Mississippi in flood has reached over 2 million.*

To complicate matters, one of our three boats was made from inexpensive PVC, a fragile material with little of the toughness of a first-rate inflatable. But we were there, the pickup had been arranged, our gear and food were ready, and we reasoned that the flow would improve as we went downstream, since I remembered from my trip eighteen years earlier that a major tributary fed in six miles below.

We were just able to float, pushing off the banks and bottom, and moved slowly downstream. We had to get out and walk the boats with great frequency, but were optimistic about the trip ahead. The canyon was magnificent. The upper portion was steeper than I had remembered and for a couple of miles the gradient reached 80 feet per mile. The canyon had also become overgrown with tamarisk (an introduced species) in the eighteen years since my last visit, making travel more difficult for hikers.

When we reached the first tributary, its flow was disappointingly low. The weather remained cold, with highs often in the forties, and we were wet to our waists all day long. Despite our hard work, by the end of the third of our nine days, we were only one-sixth of the way to the rendezvous.

On the fourth day the pace picked up and we were able to make up some of the deficit. The walls rose to nearly a thousand feet, with occasional petroglyphs and little arches at the rim. The canyon changed again and again as we moved downstream. I counted nine geomorphologically distinct regions. The many side canyons differed in character too, for many of the same reasons—changing parent material, altitude, vegetation, and so on.

Much farther downstream were miles and miles of some of the finest walls I have ever seen—grand things of exquisite color and form. I made stops for photographs where I saw the opportunity, but one day we made an extra effort to arrive early at camp to see and photograph a wall that I had known of for many years but had never actually seen.

In a remote side canyon of the Escalante, days by cross-county hike from remote trailheads, is a sandstone wall like none I have ever seen. It is many hundreds of feet high and nearly 2,000 feet wide, with exceptional desert varnish and an elegant stand of junipers at its base. The sky contained only a glimpse of blue between gray clouds, but the varnish was nevertheless a radiant blue, as if by magic. Our timing and the light fulfilled my expectations beautifully, resulting in the image on pages 110–111. The wall has been unofficially named for Philip Hyde, the photographer who first made a likeness of it about a quarter century ago.

By day six we figured that we would just make our rendezvous—if we and our gear held out, if the lower canyon didn't require more than one or two unexpected portages, and if the dreaded possibility of an impenetrable mud barrier at the head of the reservoir failed to materialize. Also by then, the only other boaters we had seen, two brothers making their second attempt at the river, had again been forced to hike out—their boats damaged beyond repair.

*We had to get out and walk our boats hundreds of times. They scraped the well-rounded rocks and sand of the bottom countless thousands of times, and we often plowed through bushes and scraped against rock walls. A few lengthy portages required de-rigging the boats. The paddles had to withstand terrific abuse without breaking, as we had to use them to push off banks and off the sometimes rocky bottom. Our partially gloved hands were repeatedly smashed into the boats and gear and abused by the elements. I could eventually count fifty small open wounds on my hands. We could hardly tie our shoes on the last morning, and it was to be several months before our hands would return to normal.*

*With almost a day to go, we reached the mouth of Coyote Gulch, where the reservoir begins to make its mark on the riverbed. The fine art of finding deeper water by the character of the surface ripples became even more difficult. We trudged and dragged our boats with difficulty for a few miles, making our final camp several miles above the rendezvous, on a muddy shore, sorry to see what the reservoir had done to the river. In the morning, we got back onto the river and found that it very quickly and suddenly gave way to deeper water, and the task of clawing our way downstream was at its end. Paddling on clear water, our speed tripled and after a couple of hours we found our good friends, right on time, headed up to meet us. We packed up the gear on a convenient island and raced off toward Bullfrog, hoping to beat the storm that was brooding over what seemed like all of Southern Utah.*

*After reaching the remote marina, we began the long drive toward St. George. It was the first of May, and as we drove over Boulder Mountain it began to snow heavily. Fifteen minutes later, we would have needed chains. It was a long day and a fitting end to the toughest river trip we had ever endured.*

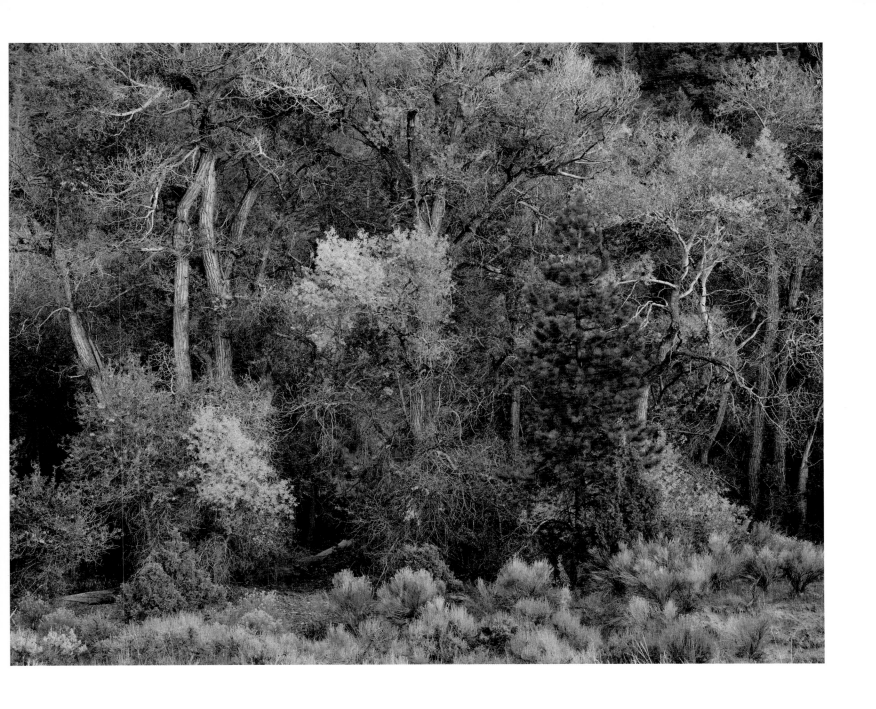

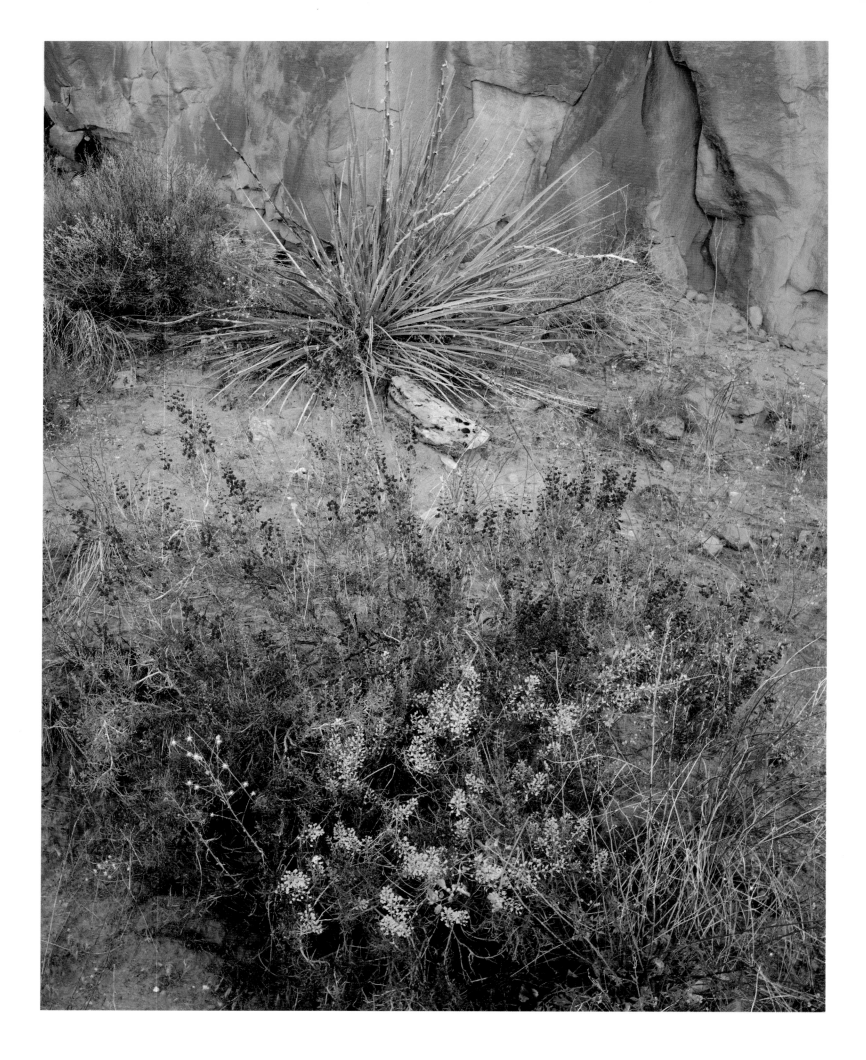

# Backpacking the Canyon

*I have found that to really comprehend the size of the Grand Canyon while standing at its rim, I need to have recently carried a heavy pack from the bottom of the abyss. At the end of a typical Canyon hike, with the pack nearly empty of food and water, I am still carrying about 57 pounds, including 30-plus pounds of camera gear. The starting weight for a long trip is over 70 pounds. At the start of a long trip into the backcountry of Yellowstone, I vividly recall the other trip members waiting to see if I'd even be able to get the pack onto my back. The vast majority of my backpacking has been in California's Sierra Nevada, where I have walked over 2,000 miles under conditions generally less extreme than those of the Canyon.*

*A great, gradual upwarp of the broad, flat region around what is now the Canyon forced the Colorado to become deeply entrenched over a period of some seven to nine million years. The upwarp is plainly visible from a light plane, and looks like an exaggerated earth's curvature. The youngest rocks in the Canyon (at the top) are over 225 million years old, and the oldest (at the bottom) more than eight times older. The south rim, about 7,000 feet above sea level, is nearly 5,000 feet above the river, and is therefore 20 to 25 degrees Fahrenheit cooler than the bottom of the canyon. The north rim is about 8,000 feet above sea level and is cooler still, with a more montane forest. Temperatures in northern Arizona exhibit a great diurnal fluctuation and a great seasonal fluctuation as well. Inclement weather usually adds another big temperature swing. On one spring knapsack trip, I was camped on the rim in 28-degree evening air, with a stiff wind and blowing snow, and two days later found myself hiking through an 85-degree oven of sun-baked black rocks.*

*Backpacking the Canyon is serious work, and requires thorough, careful planning. I usually lose about a pound a day from the exertion. Some routes are straightforward, and some are radical, cross-country challenges requiring experienced leadership. I know people whose favorite pastime is hiking here. It is always memorable.*

*For a four-day knapsack trip in the fall of 1978, I could afford only a single ten-sheet box of film (worth $11 at the time). My friend Tom Pillsbury flew three of us to the South Rim in his plane. On the last evening of our trip, we camped on the Tonto Plateau, which surrounds the inner gorge in much of the Canyon. A little gully of a side canyon led to the colossal gash that lay hidden from sight, though the precipice was less than a hundred yards away. I followed the twisting slot toward the river and experienced the inevitable shock, standing on a flat rock 30 feet below the plateau, looking 1,400 feet down to the river. By then I had but one sheet of film left. Just before dawn the next morning, I emerged from my down cocoon and once again followed the gully to the brink. I made my composition, and waited for an incredibly obliging sunrise to reach its optimum, making the exposure at the ideal moment. The result can be seen on page 107. The sun had risen precisely at that point on the rim, south of east, where it shone directly up this straightest-of-all sections of the inner gorge.*

*It was easy to see why this gorge so terrified Powell's group. Once into it, there is only one way out. Had Powell's group encountered impassable falls, they might have been swept to their deaths and Powell's remarkable journal would never have seen the light of day.*

# FROM THE LITTLE COLORADO TO THE FOOT OF THE GRAND CANYON

AUGUST 13   We are now ready to start on our way down the Great Unknown. Our boats, tied to a common stake, chafe each other as they are tossed by the fretful river. They ride high and buoyant, for their loads are lighter than we could desire. We have but a month's rations remaining. The flour has been resifted through the mosquito-net sieve; the spoiled bacon has been dried and the worst of it boiled; the few pounds of dried apples have been spread in the sun and reshrunken to their normal bulk. The sugar has all melted and gone on its way down the river. But we have a large sack of coffee. The lightening of the boats has this advantage: they will ride the waves better and we shall have but little to carry when we make a portage.

We are three quarters of a mile in the depths of the earth, and the great river shrinks into insignificance as it dashes its angry waves against the walls and cliffs that rise to the world above; the waves are but puny ripples, and we but pigmies, running up and down the sands or lost among the boulders.

We have an unknown distance yet to run, an unknown river to explore. What falls there are, we know not; what rocks beset the channel, we know not; what walls rise over the river, we know not. Ah, well! we may conjecture many things. The men talk as cheerfully as ever; jests are bandied about freely this morning; but to me the cheer is somber and the jests are ghastly.

With some eagerness and some anxiety and some misgiving we enter the canyon below and are carried along by the swift water through walls which rise from its very edge. They have the same structure that we noticed yesterday—tiers of irregular shelves below, and, above these, steep slopes to the foot of marble cliffs. We run six miles in a little more than half an hour and emerge into a more open portion of the canyon, where high hills and ledges of rock intervene between the river and the distant walls. Just at the head of this open place the river runs across a dike; that is, a fissure in the rocks, open to depths below, was filled with eruptive matter, and this on cooling was

harder than the rocks through which the crevice was made, and when these were washed away the harder volcanic matter remained as a wall, and the river has cut a gateway through it several hundred feet high and as many wide. As it crosses the wall, there is a fall below and a bad rapid, filled with boulders of trap; so we stop to make a portage. Then on we go, gliding by hills and ledges, with distant walls in view; sweeping past sharp angles of rock; stopping at a few points to examine rapids, which we find can be run, until we have made another five miles, when we land for dinner.

Then we let down with lines over a long rapid and start again. Once more the walls close in, and we find ourselves in a narrow gorge, the water again filling the channel and being very swift. With great care and constant watchfulness we proceed, making about four miles this afternoon, and camp in a cave.

AUGUST 14   At daybreak we walk down the bank of the river, on a little sandy beach, to take a view of a new feature in the canyon. Heretofore hard rocks have given us bad river; soft rocks, smooth water; and a series of rocks harder than any we have experienced sets in. The river enters the gneiss! We can see but a little way into the granite gorge, but it looks threatening.

After breakfast we enter on the waves. At the very introduction it inspires awe. The canyon is narrower than we have ever before seen it; the water is swifter; there are but few broken rocks in the channel; but the walls are set, on either side, with pinnacles and crags; and sharp, angular buttresses, bristling with wind- and wave-polished spires, extend far out into the river.

Ledges of rock jut into the stream, their tops sometimes just below the surface, sometimes rising a few or many feet above; and island ledges and island pinnacles and island towers break the swift course of the stream into chutes and eddies and whirlpools. We soon reach a place where a creek comes in from the

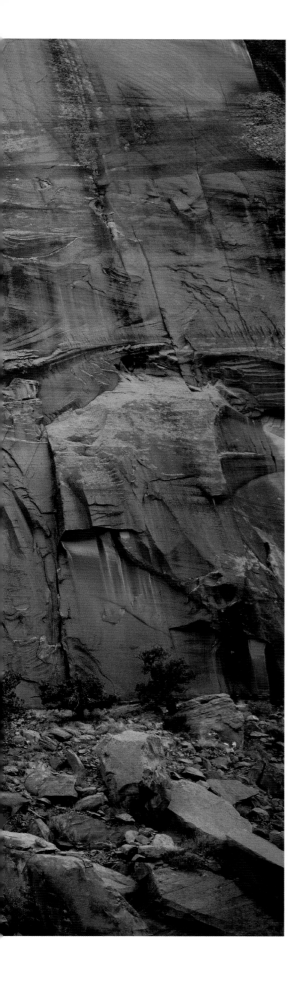

the mouth of a side canyon. Just below this there is another pile of boulders, over which we make another portage. From the foot of these rocks we can climb to another shelf, 40 or 50 feet above the water.

On this bench we camp for the night. It is raining hard, and we have no shelter, but find a few sticks which have lodged in the rocks, and kindle a fire and have supper. We sit on the rocks all night, wrapped in our *ponchos,* getting what sleep we can.

AUGUST 15   This morning we find we can let down for 300 or 400 yards and it is managed in this way: we pass along the wall by climbing from projecting point to point, sometimes near the water's edge, at other places 50 or 60 feet above, and hold the boat with a line while two men remain aboard and prevent her from being dashed against the rocks and keep the line from getting caught on the wall. In two hours we have brought them all down, as far as it is possible, in this way. A few yards below, the river strikes with great violence against a projecting rock and our boats are pulled up in a little bay above. We must now manage to pull out of this and clear the point below. The little boat is held by the bow obliquely up the stream. We jump in and pull out only a few strokes, and sweep clear of the dangerous rock. The other boats follow in the same manner and the rapid is passed.

It is not easy to describe the labor of such navigation. We must prevent the waves from dashing the boats against the cliffs. Sometimes, where the river is swift, we must put a bight of rope about a rock, to prevent the boat from being snatched from us by a wave; but where the plunge is too great or the chute too swift, we must let her leap and catch her below or the undertow will drag her under the falling water and sink her. Where we wish to run her out a little way from shore through a channel between rocks, we first throw in little sticks of driftwood and watch their course, to see where we must steer so that she will pass the channel in safety. And so we hold, and let go, and pull, and lift, and ward—among rocks, around rocks, and over rocks.

And now we go on through this solemn, mysterious way. The river is very deep, the canyon very narrow, and still obstructed, so that there is no steady flow of the stream; but the waters reel and roll and boil, and we are scarcely able to determine where we can go. Now the boat is carried to the right, perhaps close to the wall; again, she is shot into the stream, and

perhaps is dragged over to the other side, where, caught in a whirlpool, she spins about. We can neither land nor run as we please. The boats are entirely unmanageable; no order in their running can be preserved; now one, now another, is ahead, each crew laboring for its own preservation. In such a place we come to another rapid. Two of the boats run it perforce. One succeeds in landing, but there is no foothold by which to make a portage and she is pushed out again into the stream. The next minute a great reflex wave fills the open compartment; she is water-logged, and drifts unmanageable. Breaker after breaker rolls over her and one capsizes her. The men are thrown out; but they cling to the boat, and she drifts down some distance along-side of us and we are able to catch her. She is soon bailed out and the men are aboard once more; but the oars are lost, and so a pair from the "Emma Dean" is spared. Then for two miles we find smooth water.

Clouds are playing in the canyon to-day. Sometimes they roll down in great masses, filling the gorge with gloom; some-times they hang aloft from wall to wall and cover the canyon with a roof of impending storm, and we can peer long distances up and down this canyon corridor, with its cloud-roof overhead, its walls of black granite, and its river bright with the sheen of broken waters. Then a gust of wind sweeps down a side gulch and, making a rift in the clouds, reveals the blue heavens, and a stream of sunlight pours in. Then the clouds drift away into the distance, and hang around crags and peaks and pinnacles and towers and walls, and cover them with a mantle that lifts from time to time and sets them all in sharp relief. Then baby clouds creep out of side canyons, glide around points, and creep back again into more distant gorges. Then clouds arrange in strata across the canyon, with intervening vista views to cliffs and rocks beyond. The clouds are children of the heavens, and when they play among the rocks they lift them to the region above.

It rains! Rapidly little rills are formed above, and these soon grow into brooks, and the brooks grow into creeks and tumble over the walls in innumerable cascades, adding their wild music to the roar of the river. When the rain ceases the rills, brooks, and creeks run dry. The waters that fall during a rain on these steep rocks are gathered at once into the river; they could scarcely be poured in more suddenly if some vast spout ran from the clouds to the stream itself. When a storm bursts over

the canyon a side gulch is dangerous, for a sudden flood may come, and the inpouring waters will raise the river so as to hide the rocks. . . .

AUGUST 16    We must dry our rations again to-day and make oars.

The Colorado is never a clear stream, but for the past three or four days it has been raining much of the time, and the floods poured over the walls have brought down great quantities of mud, making it exceedingly turbid now. The little affluent which we have discovered here is a clear, beautiful creek, or river, as it would be termed in this western country, where streams are not abundant. We have named one stream, away above, in honor of the great chief of the "Bad Angels," and as this is in beautiful contrast to that, we conclude to name it "Bright Angel."

Early in the morning the whole party starts up to explore the Bright Angel River, with the special purpose of seeking timber from which to make oars. A couple of miles above we find a large pine log, which has been floated down from the plateau, probably from an altitude of more than 6,000 feet, but not many miles back. On its way it must have passed over many cataracts and falls, for it bears scars in evidence of the rough usage which it has received. The men roll it on skids, and the work of sawing oars is commenced. . . .

Late in the afternoon I return and go up a little gulch just above this creek, about 200 yards from camp, and discover the ruins of two or three old houses, which were originally of stone laid in mortar. Only the foundations are left, but irregular blocks, of which the houses were constructed, lie scattered about. In one room I find an old mealing-stone, deeply worn, as if it had been much used. A great deal of pottery is strewn around, and old trails, which in some places are deeply worn into the rocks, are seen.

It is ever a source of wonder to us why these ancient people sought such inaccessible places for their homes. They were, doubtless, an agricultural race, but there are no lands here of any considerable extent that they could have cultivated. To the west of Oraibi, one of the towns in the Province of Tusayan, in northern Arizona, the inhabitants have actually built little terraces along the face of the cliff where a spring gushes out, and thus made their sites for gardens. It is possible that the ancient

inhabitants of this place made their agricultural lands in the same way. But why should they seek such spots? Surely the country was not so crowded with people as to demand the utilization of so barren a region. The only solution suggested of the problem is this: We know that for a century or two after the settlement of Mexico many expeditions were sent into the country now comprising Arizona and New Mexico, for the purpose of bringing the town-building people under the dominion of the Spanish government. Many of their villages were destroyed, and the inhabitants fled to regions at that time unknown; and there are traditions among the people who inhabit the pueblos that still remain that the canyons were these unknown lands. It may be these buildings were erected at that time; sure it is that they have a much more modern appearance than the ruins scattered over Nevada, Utah, Colorado, Arizona, and New Mexico. Those old Spanish conquerors had a monstrous greed for gold and a wonderful lust for saving souls. Treasures they must have, if not on earth, why, then, in heaven; and when they failed to find heathen temples bedecked with silver, they propitiated Heaven by seizing the heathen themselves. . . .

AUGUST 17    Our rations are still spoiling; the bacon is so badly injured that we are compelled to throw it away. By an accident, this morning, the saleratus was lost overboard. We have now only musty flour sufficient for ten days and a few dried apples, but plenty of coffee. We must make all haste possible. If we meet with difficulties such as we have encountered in the canyon above, we may be compelled to give up the expedition and try to reach the Mormon settlements to the north.

Our hopes are that the worst places are passed, but our barometers are all so much injured as to be useless, and so we have lost our reckoning in altitude, and know not how much descent the river has yet to make.

The stream is still wild and rapid and rolls through a narrow channel. we make but slow progress, often landing against a wall and climbing around some point to see the river below. Although very anxious to advance, we are determined to run with great caution, lest by another accident we lose our remaining supplies. How precious that little flour has become! We divide it among the boats and carefully store it away, so that it can be lost only by the loss of the boat itself.

We make ten miles and a half, and camp among the rocks on the right. We have had rain from time to time all day, and have been thoroughly drenched and chilled; but between showers the sun shines with great power and the mercury in our thermometers stands at 115°, so that we have rapid changes from great extremes, which are very disagreeable. It is especially cold in the rain to-night. The little canvas we have is rotten and useless; the rubber *ponchos* with which we started from Green River City have all been lost; more than half the party are without hats, not one of us has an entire suit of clothes, and we have not a blanket apiece. So we gather driftwood and build a fire; but after supper the rain, coming down in torrents, extinguishes it, and we sit up all night on the rocks, shivering, and are more exhausted by the night's discomfort than by the day's toil.

AUGUST 18   The day is employed in making portages and we advance but two miles on our journey. Still it rains. . . .

AUGUST 19   Rain again this morning. We are in our granite prison still, and the time until noon is occupied in making a long, bad portage.

After dinner, in running a rapid the pioneer boat is upset by a wave. We are some distance in advance of the larger boats. The river is rough and swift and we are unable to land, but cling to the boat and are carried down stream over another rapid. The men in the boats above see our trouble, but they are caught in whirlpools and are spinning about in eddies, and it seems a long time before they come to our relief. At last they do come; our boat is turned right side up and bailed out; the oars, which fortunately have floated along in company with us, are gathered up, and on we go, without even landing. The clouds break away and we have sunshine again.

Soon we find a little beach with just room enough to land. Here we camp, but there is no wood. Across the river and a little way above, we see some driftwood lodged in the rocks. So we bring two boat loads over, build a huge fire, and spread everything to dry. It is the first cheerful night we have had for a week —a warm, drying fire in the midst of the camp, and a few bright stars in our patch of heavens overhead.

AUGUST 20   The characteristics of the canyon change this morning. The river is broader, the walls more sloping, and composed of black slates that stand on edge. These nearly vertical slates are washed out in places—that is, the softer beds are washed out between the harder, which are left standing. In this way curious little alcoves are formed, in which are quiet bays of water, but on a much smaller scale than the great bays and buttresses of Marble Canyon.

The river is still rapid and we stop to let down with lines several times, but make greater progress, as we run ten miles. We camp on the right bank. . . .

AUGUST 21   We start early this morning, cheered by the prospect of a fine day and encouraged also by the good run made yesterday. A quarter of a mile below camp the river turns abruptly to the left, and between camp and that point is very swift, running down in a long, broken chute and piling up against the foot of the cliff, where it turns to the left. We try to pull across, so as to go down on the other side, but the waters are swift and it seems impossible for us to escape the rock below; but, in pulling across, the bow of the boat is turned to the farther shore, so that we are swept broadside down and are prevented by the rebounding waters from striking against the wall. We toss about for a few seconds in these billows and are then carried past the danger. Below, the river turns again to the right, the canyon is very narrow, and we see in advance but a short distance. The water, too, is very swift, and there is no landing-place. From around this curve there comes a mad roar, and down we are carried with a dizzying velocity to the head of another rapid. On either side high over our heads there are overhanging granite walls, and the sharp bends cut off our view, so that a few minutes will carry us into unknown waters. Away we go on one long, winding chute. I stand on deck, supporting myself with a strap fastened on either side of the gunwale. The boat glides rapidly where the water is smooth, then, striking a wave, she leaps and bounds like a thing of life, and we have a wild, exhilarating ride for ten miles, which we make in less than an hour. The excitement is so great that we forget the danger until we hear the roar of a great fall below; then we back on our oars and are carried slowly toward its head and succeed in landing just above and find that we have to make another portage. At this we are engaged until some time after dinner.

Just here we run out of the granite. Ten miles in less than half a day, and limestone walls below. Good cheer returns; we forget the storms and the gloom and the cloud-covered canyons and the black granite and the raging river, and push our boats from shore in great glee.

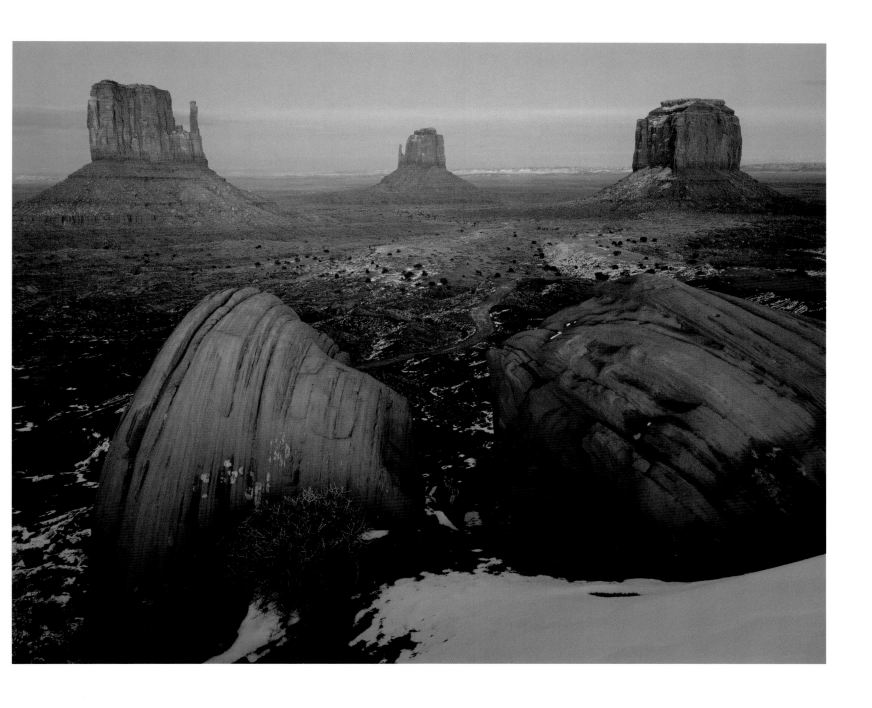

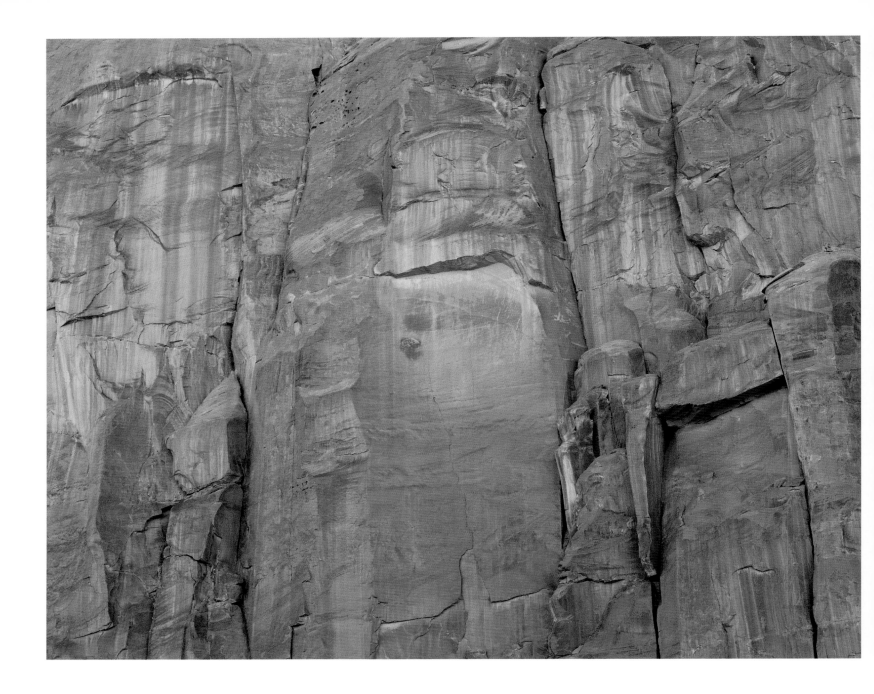

Though we are out of the granite, the river is still swift, and we wheel about a point again to the right, and turn, so as to head back in the direction from which we came; this brings the granite in sight again, with its narrow gorge and black crags; but we meet with no more great falls or rapids. Still, we run cautiously and stop from time to time to examine some places which look bad. Yet we make ten miles this afternoon; twenty miles in all to-day.

AUGUST 22   We come to rapids again this morning and are occupied several hours in passing them, letting the boats down from rock to rock with lines for nearly half a mile, and then have to make a long portage. . . .

After my return to the boats we run another mile and camp for the night. We have made but little over seven miles to-day, and a part or our flour has been soaked in the river again.

AUGUST 23   Our way to-day is again through marble walls. Now and then we pass for a short distance through patches of granite, like hills thrust up into the limestone. At one of these places we have to make another portage, and, taking advantage of the delay, I go up a little stream to the north, wading it all the way, sometimes having to plunge in to my neck, in other places being compelled to swim across little basins that have been excavated at the foot of the falls. Along its course are many cascades and springs, gushing out from the rocks on either side. Sometimes a cottonwood tree grows over the water. I come to one beautiful fall, of more than 150 feet, and climb around it to the right on the broken rocks. Still going up, the canyon is found to narrow very much, being but 15 or 20 feet wide; yet the walls rise on either side many hundreds of feet, perhaps thousands; I can hardly tell.

In some places the stream has not excavated its channel down vertically through the rocks, but has cut obliquely, so that one wall overhangs the other. In other places it is cut vertically above and obliquely below, or obliquely above and vertically below, so that it is impossible to see out overhead. But I can go no farther; the time which I estimated it would take to make the portage has almost expired, and I start back on a round trot, wading in the creek where I must and plunging through basins. The men are waiting for me, and away we go on the river.

Just after dinner we pass a stream on the right, which leaps into the Colorado by a direct fall of more than 100 feet, forming a beautiful cascade. There is a bed of very hard rock above, 30 or 40 feet in thickness, and there are much softer beds below. The hard beds above project many yards beyond the softer, which are washed out, forming a deep cave behind the fall, and the stream pours through a narrow crevice above into a deep pool below. Around on the rocks in the cavelike chamber are set

beautiful ferns, with delicate fronds and enameled stalks. The frondlets have their points turned down to form spore cases. It has very much the appearance of the maidenhair fern, but is much larger. This delicate foliage covers the rocks all about the fountain, and gives the chamber great beauty. But we have little time to spend in admiration; so on we go.

We make fine progress this afternoon, carried along by a swift river, shooting over the rapids and finding no serious obstructions. The canyon walls for 2,500 or 3,000 feet are very regular, rising almost perpendicularly, but here and there set with narrow steps, and occasionally we can see away above the broad terrace to distant cliffs.

We camp to-night in a marble cave, and find on looking at our reckoning that we have run 22 miles.

AUGUST 24   The canyon is wider to-day. The walls rise to a vertical height of nearly 3,000 feet. In many places the river runs under a cliff in great curves, forming amphitheaters half-dome shaped.

Though the river is rapid, we meet with no serious obstructions and run 20 miles. How anxious we are to make up our reckoning every time we stop, now that our diet is confined to plenty of coffee, a very little spoiled flour, and very few dried apples! It has come to be a race for a dinner. Still, we make such fine progress that all hands are in good cheer, but not a moment of daylight is lost.

AUGUST 25   We make 12 miles this morning, when we come to monuments of lava standing in the river,—low rocks mostly, but some of them shafts more than a hundred feet high. Going on down three or four miles, we find them increasing in number. Great quantities of cooled lava and many cinder cones are seen on either side; and then we come to an abrupt cataract. Just over the fall on the right wall a cinder cone, or extinct volcano, with a well-defined crater, stands on the very brink of the canyon. This, doubtless, is the one we saw two or three days ago. From this volcano vast floods of lava have been poured down into the river, and a stream of molten rock has run up the canyon three or four miles and down we know not how far. Just where it poured over the canyon wall is the fall. The whole north side as far as we can see is lined with the black basalt, and high up on the opposite wall are patches of the same material, resting on the benches and filling old alcoves and caves, giving the wall a spotted appearance.

The rocks are broken in two along a line which here crosses the river, and the beds we have seen while coming down the canyon for the last 30 miles have dropped 800 feet on the lower side of the line, forming what geologists call a "fault." The volcanic cone stands directly over the fissure thus formed. On the

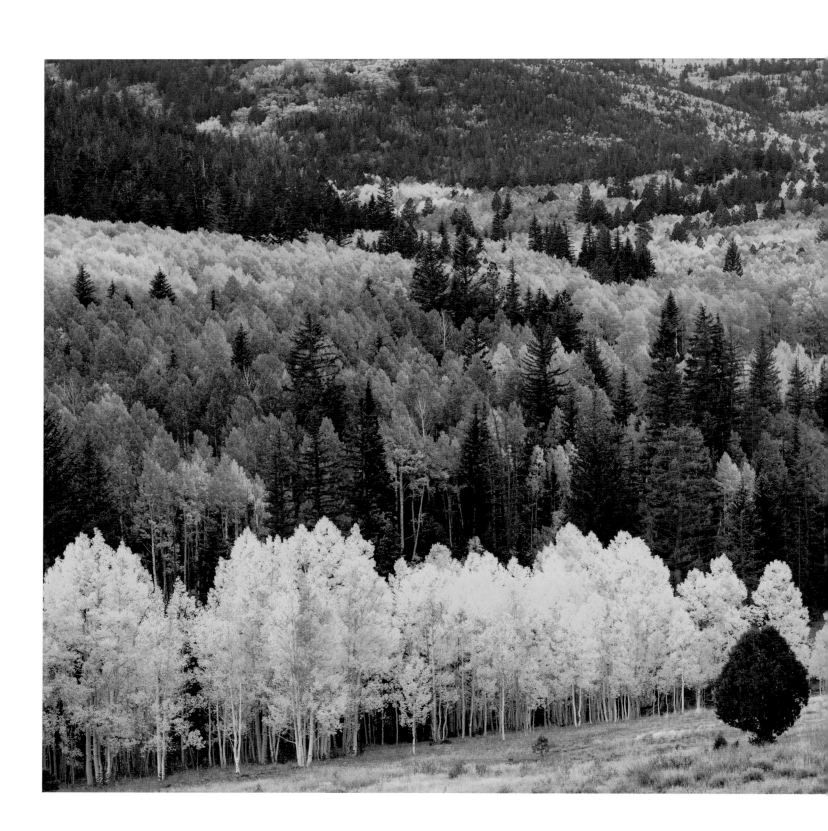

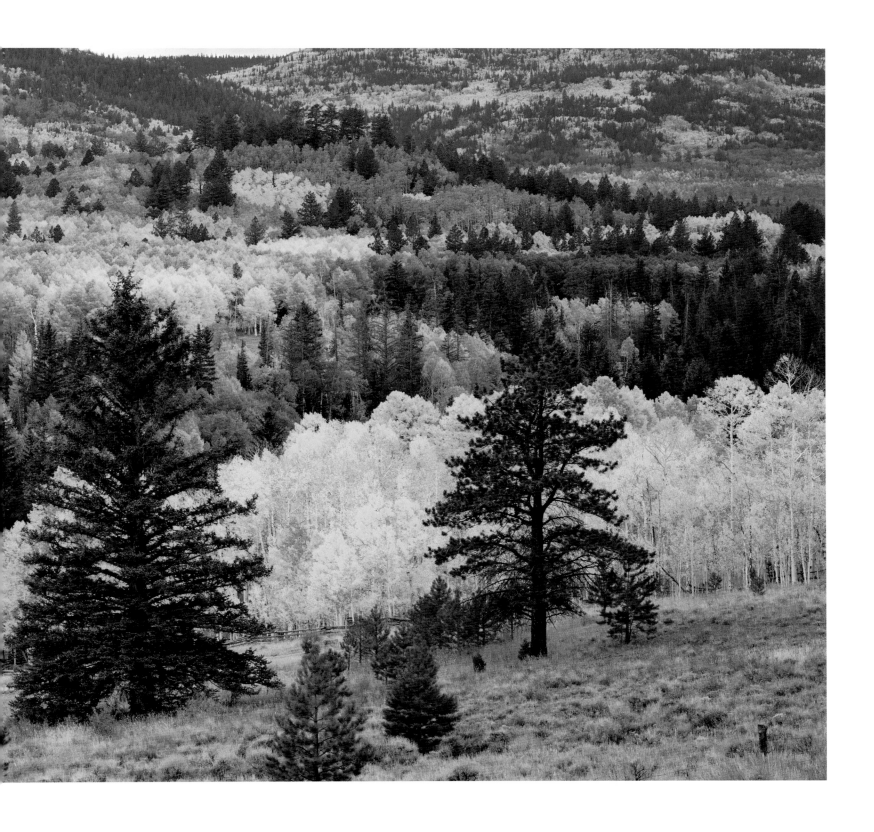

left side of the river, opposite, mammoth springs burst out of this crevice, 100 or 200 feet above the river, pouring in a stream quite equal in volume to the Colorado Chiquito.

This stream seems to be loaded with carbonate of lime, and the water, evaporating, leaves an incrustation on the rocks; and this process has been continued for a long time, for extensive deposits are noticed in which are basins with bubbling springs. The water is salty.

We have to make a portage here, which is completed in about three hours; then on we go.

We have no difficulty as we float along, and I am able to observe the wonderful phenomena connected with this flood of lava. The canyon was doubtless filled to a height of 1,200 or 1,500 feet, perhaps by more than one flood. This would dam the water back; and in cutting through this great lava bed, a new channel has been formed, sometimes on one side, sometimes on the other. The cooled lava, being of firmer texture than the rocks of which the walls are composed, remains in some places; in others a narrow channel has been cut, leaving a line of basalt on either side. It is possible that the lava cooled faster on the sides against the walls and that the center ran out; but of this we can only conjecture. There are other places where almost the whole of the lava is gone, only patches of it being seen where it has caught on the walls. As we float down we can see that it ran out into side canyons. In some places this basalt has a fine, columnar structure, often in concentric prisms, and masses of these concentric columns have coalesced. In some places, when the flow occurred the canyon was probably about the same depth that it is now, for we can see where the basalt has rolled out on the sands, and—what seems curious to me— the sands are not melted or metamorphosed to any appreciable extent. In places the bed of the river is of sandstone or limestone, in other places of lava, showing that it has all been cut out again where the sandstones and limestones appear; but there is a little yet left where the bed is of lava.

What a conflict of water and fire there must have been here! Just imagine a river of molten rock running down into a river of melted snow. What a seething and boiling of the waters; what clouds of steam rolled into the heavens!

Thirty-five miles today. Hurrah!

AUGUST 26    The canyon walls are steadily becoming higher as we advance. They are still bold and nearly vertical up to the terrace. . . .

Since we left the Colorado Chiquito we have seen no evidences that the tribe of Indians inhabiting the plateaus on either side ever come down to the river; but about eleven o'clock today we discover an Indian garden at the foot of the wall on the right, just where a little stream with a narrow flood plain comes down through a side canyon. Along the valley the Indians have planted corn, using for irrigation the water which bursts out in springs at the foot of the cliff. The corn is looking quite well, but it is not sufficiently advanced to give us roasting ears; but there are some nice green squashes. We carry ten or a dozen of these on board our boats and hurriedly leave, not willing to be caught in the robbery, yet excusing ourselves by pleading our great want. We run down a short distance to where we feel certain no Indian can follow, and what a kettle of squash sauce we make! True, we have no salt with which to season it, but it makes a fine addition to our unleavened bread and coffee. Never was fruit so sweet as these stolen squashes.

After dinner we push on again and make fine time, finding many rapids, but none so bad that we cannot run them with safety; and when we stop, just at dusk, and foot up our reckoning, we find we have run 35 miles again. A few days like this, and we are out of prison.

We have a royal supper—unleavened bread, green squash sauce, and strong coffee. We have been for a few days on half rations, but now have no stint of roast squash.

AUGUST 27    This morning the river takes a more southerly direction. The dip of the rocks is to the north and we are running rapidly into lower formations. Unless our course changes we shall very soon run again into the granite. This gives some anxiety. Now and then the river turns to the west and excites hopes that are soon destroyed by another turn to the south. About nine o'clock we come to the dreaded rock. It is with no little misgiving that we see the river enter these black, hard walls. At its very entrance we have to make a portage; then let down with lines past some ugly rocks. We run a mile or two farther, and then the rapids below can be seen.

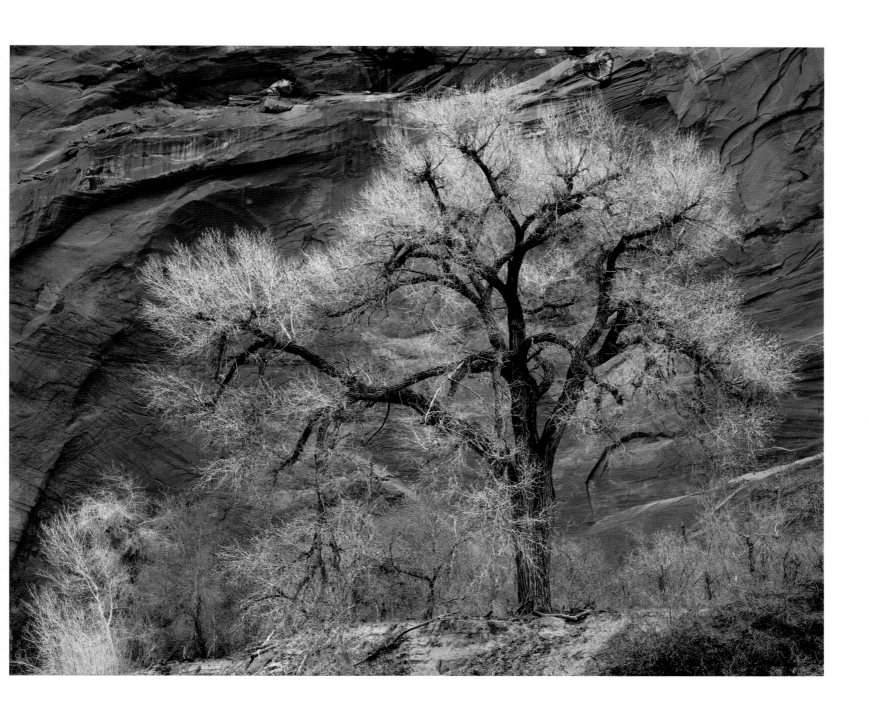

About eleven o'clock we come to a place in the river which seems much worse than any we have yet met in all its course. A little creek comes down from the left. We land first on the right and clamber up over the granite pinnacles for a mile or two, but can see no way by which to let down, and to run it would be sure destruction. After dinner we cross to examine on the left. High above the river we can walk along on the top of the granite, which is broken off at the edge and set with crags and pinnacles, so that it is very difficult to get a view of the river at all. In my eagerness to reach a point where I can see the roaring fall below, I go too far on the wall, and can neither advance nor retreat. I stand with one foot on a little projecting rock and cling with my hand fixed in a little crevice. Finding I am caught here, suspended 400 feet above the river, into which I must fall if my footing fails, I call for help. The men come and pass me a line, but I cannot let go of the rock long enough to take hold of it. Then they bring two or three of the largest oars. All this takes time which seems very precious to me; but at last they arrive. The blade of one of the oars is pushed into a little crevice in the rock beyond me in such a manner that they can hold me pressed against the wall. Then another is fixed in such a way that I can step on it; and thus I am extricated.

Still another hour is spent in examining the river from this side, but no good view of it is obtained; so now we return to the side that was first examined, and the afternoon is spent in clambering among the crags and pinnacles and carefully scanning the river again. We find that the lateral streams have washed boulders into the river, so as to form a dam, over which the water makes a broken fall of 18 or 20 feet; then there is a rapid, beset with rocks, for 200 or 300 yards, while on the other side, points of the wall project into the river. Below, there is a second fall; how great, we cannot tell. Then there is a rapid, filled with huge rocks, for 100 or 200 yards. At the bottom of it, from the right wall, a great rock projects quite halfway across the river. It has a sloping surface extending up stream, and the water, coming down with all the momentum gained in the falls and rapids above, rolls up this inclined plane many feet, and tumbles over to the left. I decide that it is possible to let down over the first fall, then run near the right cliff to a point just above the second, where we can pull out into a little chute, and, having run

over that in safety, if we pull with all our power across the stream, we may avoid the great rock below. On my return to the boat I announce to the men that we are to run it in the morning. Then we cross the river and go into camp for the night on some rocks in the mouth of the little side canyon.

After supper Captain Howland asks to have a talk with me. We walk up the little creek a short distance, and I soon find that his object is to remonstrate against my determination to proceed. He thinks that we had better abandon the river here. Talking with him, I learn that he, his brother, and William Dunn have determined to go no farther in the boats. So we return to camp. Nothing is said to the other men.

For the last two days our course has not been plotted. I sit down and do this now, for the purpose of finding where we are by dead reckoning. It is a clear night, and I take out the sextant to make observation for latitude, and I find that the astronomic determination agrees very nearly with that of the plot—quite as closely as might be expected from a meridian observation on a planet. In a direct line, we must be about 45 miles from the mouth of the Rio Virgen. If we can reach that point, we know that there are settlements up that river about 20 miles. This 45 miles in a direct line will probably be 80 or 90 by the meandering line of the river. But then we know that there is comparatively open country for many miles above the mouth of the Virgen, which is our point of destination.

As soon as I determine all this, I spread my plot on the sand and wake Howland, who is sleeping down by the river, and show him where I suppose we are, and where several Mormon settlements are situated.

We have another short talk about the morrow, and he lies down again; but for me there is no sleep. All night long I pace up and down a little path, on a few yards of sand beach, along by the river. Is it wise to go on? I go to the boats again to look at our rations. I feel satisfied that we can get over the danger immediately before us; what there may be below I know not. From our outlook yesterday on the cliffs, the canyon seemed to make another great bend to the south, and this, from our experience heretofore, means more and higher granite walls. I am not sure that we can climb out of the canyon here, and, if at the top of the wall, I know enough of the country to be certain that it is a desert of rock and sand between this and the nearest Mormon town, which, on the most direct line, must be 75 miles

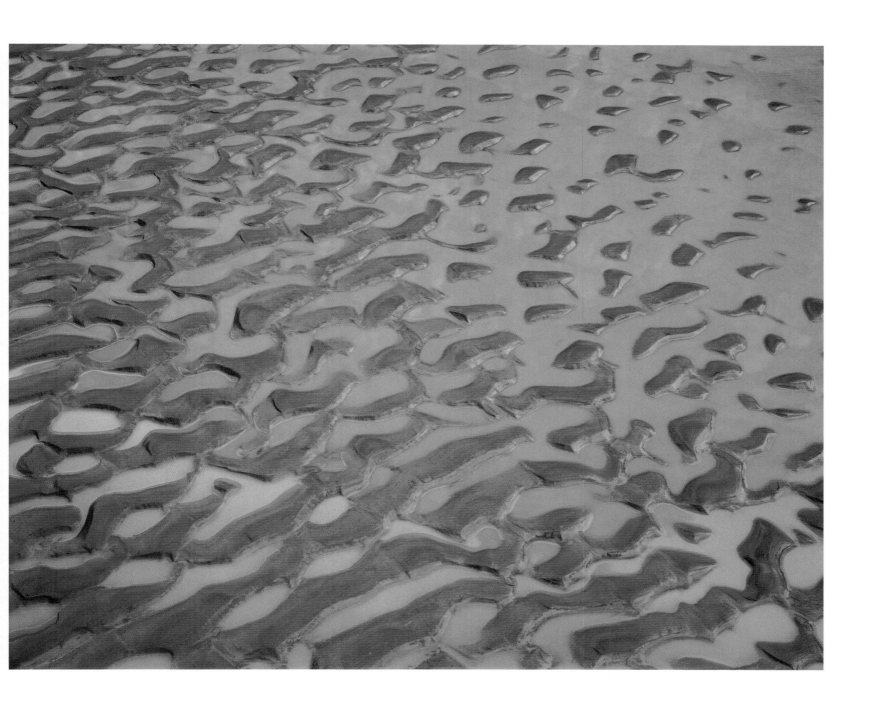

away. True, the late rains have been favorable to us, should we go out, for the probabilities are that we shall find water still standing in holes; and at one time I almost conclude to leave the river. But for years I have been contemplating this trip. To leave the exploration unfinished, to say that there is a part of the canyon which I cannot explore, having already nearly accomplished it, is more than I am willing to acknowledge, and I determine to go on.

I wake my brother and tell him of Howland's determination, and he promises to stay with me; then I call up Hawkins, the cook, and he makes a like promise; then Sumner and Bradley and Hall, and they all agree to go on.

AUGUST 28   At last daylight comes and we have breakfast without a word being said about the future. The meal is as solemn as a funeral. After breakfast I ask the three men if they still think it best to leave us. The elder Howland thinks it is, and Dunn agrees with him. The younger Howland tries to persuade them to go on with the party; failing in which, he decides to go with his brother.

Then we cross the river. The small boat is very much disabled and unseaworthy. With the loss of hands, consequent on the departure of the three men, we shall not be able to run all of the boats; so I decide to leave my "Emma Dean."

Two rifles and a shotgun are given to the men who are going out. I ask them to help themselves to the rations and take what they think to be a fair share. This they refuse to do, saying they have no fear but that they can get something to eat; but Billy, the cook, has a pan of biscuits prepared for dinner, and these he leaves on a rock.

Before starting, we take from the boat our barometers, fossils, the minerals, and some ammunition and leave them on the rocks. We are going over this place as light as possible. The three men help us lift our boats over a rock 25 or 30 feet high and let them down again over the first fall, and now we are all ready to start. The last thing before leaving, I write a letter to my wife and give it to Howland. Sumner gives him his watch, directing that it be sent to his sister should he not be heard from again. The records of the expedition have been kept in duplicate. One set of these is given to Howland; and now we are ready. For the

last time they entreat us not to go on, and tell us that it is madness to set out in this place; that we can never get safely through it; and, further, that the river turns again to the south into the granite, and a few miles of such rapids and falls will exhaust our entire stock of rations, and then it will be too late to climb out. Some tears are shed; it is rather a solemn parting; each party thinks the other is taking the dangerous course.

My old boat left, I go on board of the "Maid of the Canyon." The three men climb a crag that overhangs the river to watch us off. The "Maid of the Canyon" pushes out. We glide rapidly along the foot of the wall, just grazing one great rock, then pull out a little into the chute of the second fall and plunge over it. The open compartment is filled when we strike the first wave below, but we cut through it, and then the men pull with all their power toward the left wall and swing clear of the dangerous rock below all right. We are scarcely a minute in running it, and find that, although it looked bad from above, we have passed many places that were worse.

The other boat follows without more difficulty. We land at the first practicable point below, and fire our guns, as a signal to the men above that we have come over in safety. Here we remain a couple of hours, hoping that they will take the smaller boat and follow us. We are behind a curve in the canyon and cannot see up to where we left them, and so we wait until their coming seems hopeless, and then push on.

And now we have a succession of rapids and falls until noon, all of which we run in safety. Just after dinner we come to another bad place. A little stream comes in from the left, and below there is a fall, and still below another fall. Above, the river tumbles down, over and among the rocks, in whirlpools and great waves, and the waters are lashed into mad, white foam. We run along the left, above this, and soon see that we cannot

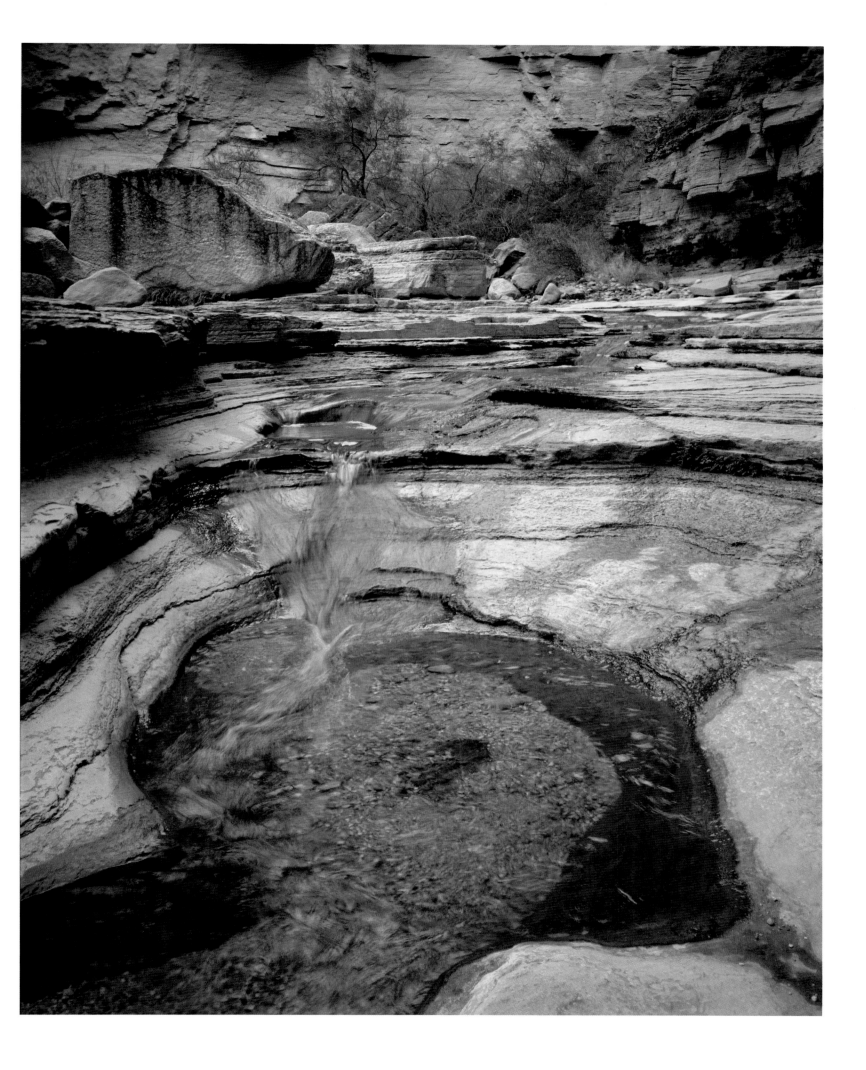

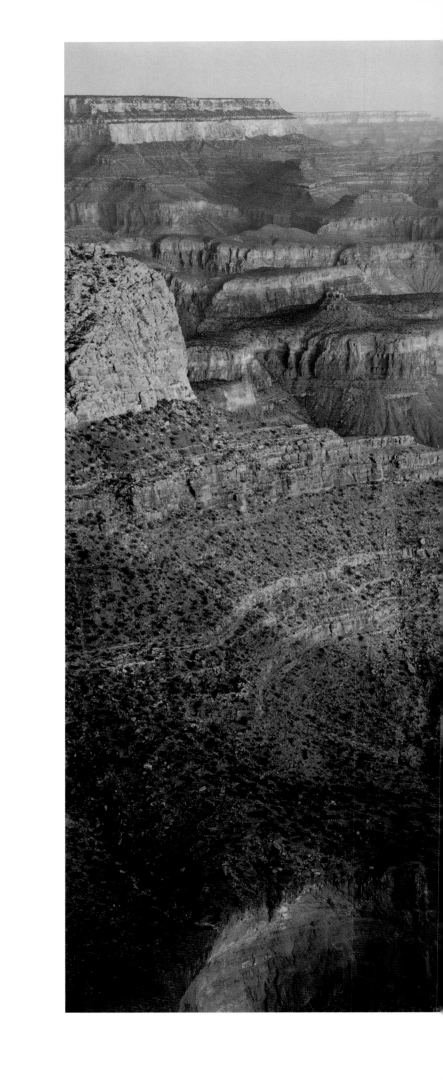

# Raft the Colorado

*Perhaps the greatest wilderness experience readily available in the contiguous United States is a trip by raft through the Grand Canyon. By 1980 over seventy thousand people had followed in the wake of Major Powell and his incredibly brave and hearty crew of nine. In the spring of that year Tom Pillsbury, who had introduced me to backpacking in both the canyons of the Escalante and the Grand Canyon, invited me on a private rafting trip through the Canyon.*

*I had done quite a bit of rafting by then, but this stretch of the Colorado is special, as it includes a significant percentage of the continent's most spectacular navigable rapids. The river drops an average of 9 feet per mile for these 250 or so free-flowing miles. This might sound unspectacular, but the drop is variable: a leisurely 4-foot-per-mile gradient will give way to a heart-stopping plunge of many feet within a few dozen yards. The rapids have been created where intense storm runoff from side canyons has dumped boulders into the riverbed. In 1966 Crystal Rapid was transformed into a boat-eating monster as a result of such a storm.*

*The only put-in, defined as Mile 0, is at Lee's Ferry (elevation 3,116 feet). Phantom Ranch, at Mile 87 (elevation 2,430 feet), is the next place where passengers may join or depart by hiking the vertical mile from the South Rim. Many rafters leave the Canyon at Diamond Creek, Mile 225 (elevation about 970 feet), thereby missing both the lower 40 miles of canyon and about 40 tedious miles of upper "Lake" Mead. The reservoir floods roughly 25 miles of the Canyon.*

*Our destination was Pierce Ferry, Mile 279 (elevation about 900 feet), on the bleak shore of the reservoir, and we had scheduled a full twenty-one days to cover the distance. The trip deserves about forty days to fully explore many of the more interesting side canyons. Also, the current was slow in late March, as the upstream dam was saving the spring runoff for peak summer power generation, so nearly continuous rowing would be required and few layovers were possible.*

*For the first few days the canyon deepened steadily. Huge walls rose to more walls and still more. At times, atmospheric effects created by the scale made it look as though the Creator were about to emerge from around a bend.*

*On the fourth morning I climbed the 500 vertical feet from our camp at Nankoweap to the site of a much visited Anasazi ruin, not anticipating the view it would afford. The photograph I made there shows no less than 3,200 vertical feet of rock, and the center of the hazy canyon wall in the distance was a full four miles from where I stood. Our boats and camp provide a touch of scale. The image, on pages 58–59, has long been a favorite.*

*We drifted slowly past more than a thousand miles of the huge, staggered cliffs forming the countless side canyons. The rock forms of the Canyon possess a strong character of simultaneous order and chaos. This chaotic regularity is typical of landforms and feels both elegant and profoundly relaxing to me. I am sure this is not a learned reaction, rather somehow proof of our natural origins.*

*The Canyon is not a monolith, although it is gashed into a single great upwarp of the Earth's crust. It has several regions and characters, and contains many scenic surprises. One of mine was discovering a brilliant aqua blue Little Colorado instead of the rusty red one I had expected. Minerals leached into the river turn it aqua, but when the river floods, it carries a heavy load of silt that turns it red. Also memorable were the travertine waterfall of Fern Glen, the grooved walls of Matkatameba, the banana-shaped sky of Sinyala, the travertine weirs of Havasu Creek, and the Great Pumpkin of Pumpkin Springs.*

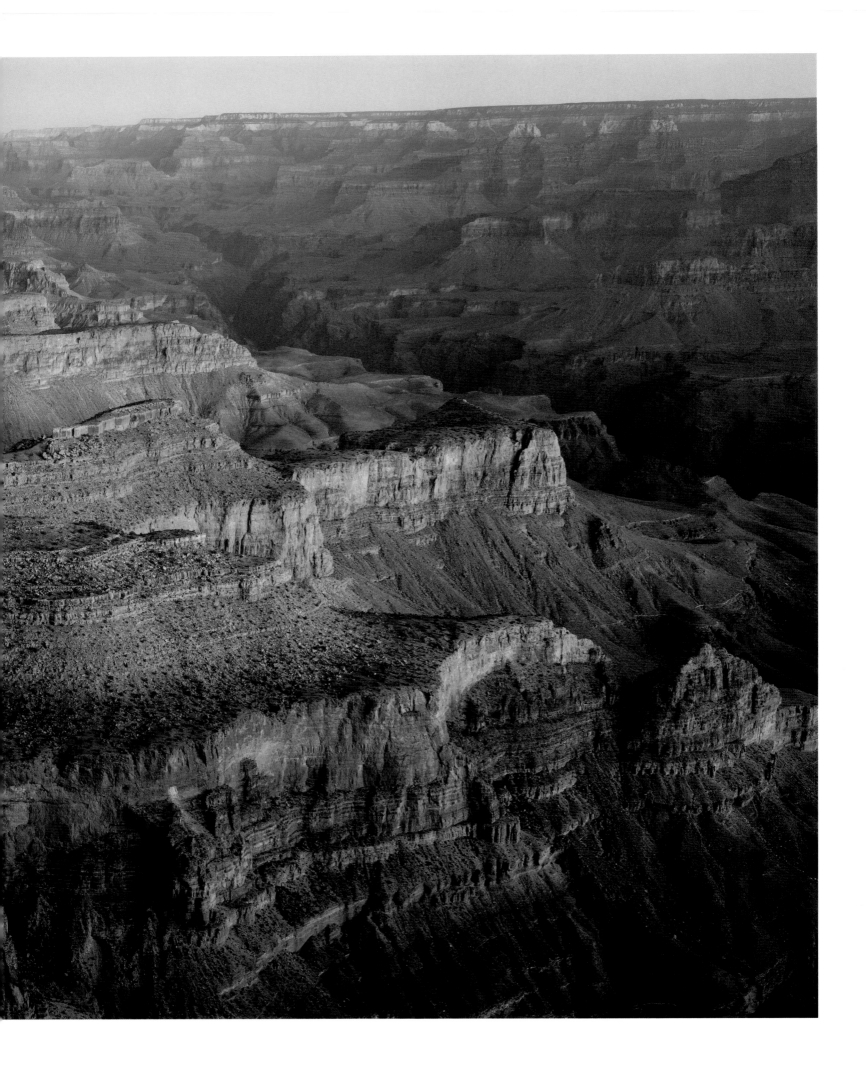

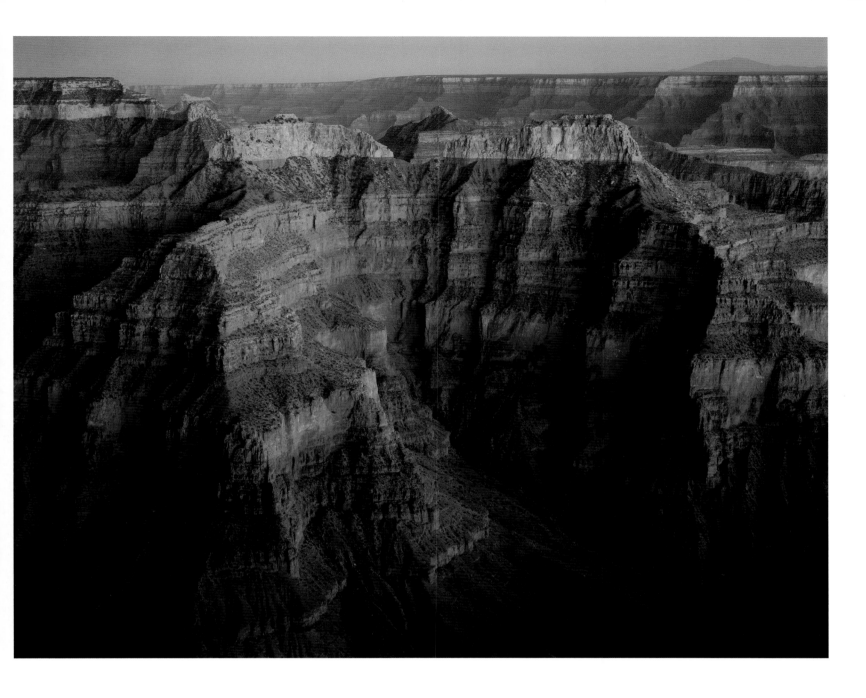

Despite the considerable flow of pilgrims, we enjoyed being the very first ones that year to leave our footprints on the sand. We saw signs of backpackers in only three spots and no other boating parties. Just ourselves and the wildlife.

The rapids were quite exciting—between our six rafts and three kayaks we experienced four flips and got good and wet more than a hundred times. In Alaska, the bears tend to dominate discussion; in the Canyon, it's the rapids. But the most impressive feature of this place is the immensity of the canyon that the river has made possible.

The other canyons of the Colorado are often lusher, more inviting places; many have smoother and, I think, lovelier stone walls. The Grand Canyon reigns supreme among the canyons where sheer magnificence is concerned, however, and I have often told people that if they could only make one wilderness journey during their lives, it ought to be a long, oar-powered trip through the Canyon, in one of the cooler times of the year. The experience is simply overwhelming. When we finally emerged, where the river flows out from a notch in a long wall of cliffs into a sudden, vast openness, most of us wept at the sight of the horizon—something we hadn't seen for what seemed a lifetime.

131

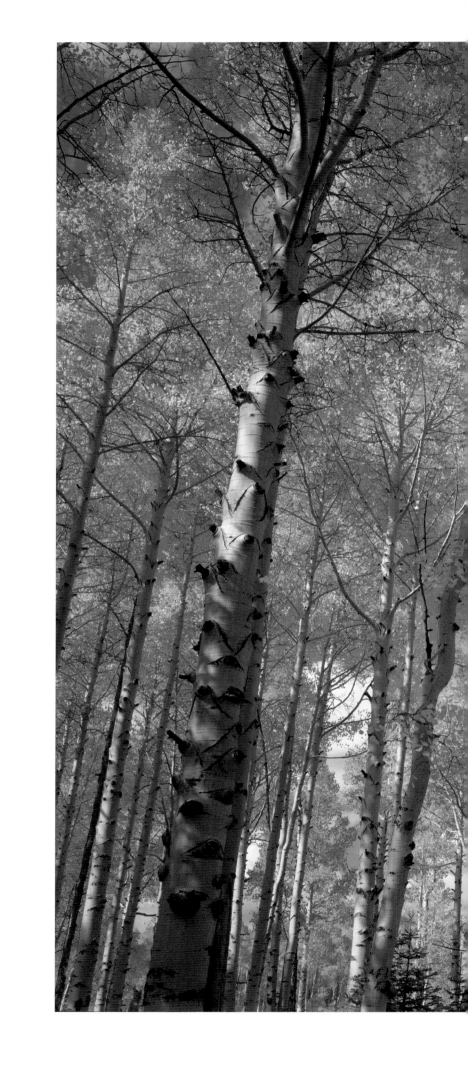

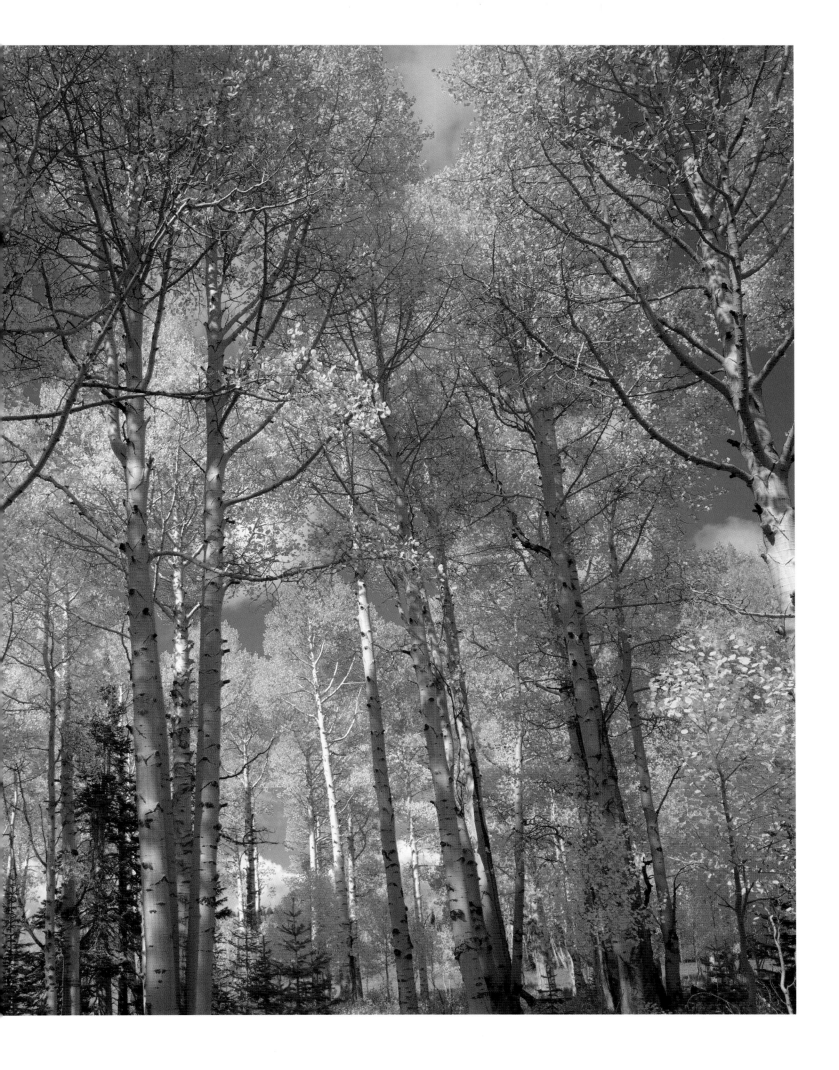

# TECHNICAL NOTES

This book is the first ever made with a new system of digital technologies for rendering color photographic images that affords essentially perfect control to the photographer—a system that deftly combines the process of creating fine photographic prints by digital means with the making of digital color separation files for publication.

For over twenty-eight years it has been my dream to make color photographs that truly do justice to the subject matter they represent. To that end, the greatest part of my work for all those years has been devoted to researching and developing new processes and techniques for rendering images captured with my 4×5-inch view camera. Finally, a new system has made it possible to exercise complete control over color images with a desktop computer, while working in a practical and elegant way at the high resolutions required for large-format printmaking.

The system effectively combines the techniques and advantages of my sophisticated traditional darkroom with those of prepress and more, resulting in a unified and flexible process that is fully under my control. This allows me to better realize my original vision. Also, as I produce images for publication, they are simultaneously readied for other uses, including further publication, stock sales, and the making of extremely high-quality photographic prints.

Employing these new technologies, images can now be manipulated with unprecedented ease and sophistication. For example, one can artificially juxtapose or combine portions of many different images. My own interest, however, is in revealing more fully and successfully what I have actually seen. These new tools have allowed the realization of this unique collection of my work, which in many cases shows the images as they were meant to be for the very first time. Many annoying flaws of various kinds have been repaired or removed by digital means. I have rectified old mistakes, such as having neglected to use a UV or light balancing filter, which had resulted in overly bluish shadows. I restored the color of a few older Ektachrome E-3 transparencies that had faded, and I even corrected the perspective of an image that couldn't be properly managed with the view camera.

My main reason, however, for using digital processes for rendering images captured with the camera is to achieve the finest possible expression of the photographs. They have been dodged and burned with ease and precision. The overall contrast and the tone curve of each image have been carefully adjusted to best suit the subject. Color balance has been optimized, saturation adjusted, and where necessary, individual hues have been corrected. Local contrast and color adjustments have also been made. In some cases, extreme tone control has been utilized to correct two regions of an image as if each were a separate photograph. This new rendering process is more flexible, can produce better results, and requires about one-fifth as much time to use as the only acceptable prior alternative—making carefully manipulated prints in the darkroom for reproduction. In spite of the great control over the image afforded by the computer, there is a limit to what you can do—you can't turn a photograph of this sort into something it isn't. There is still no substitute for insightful camera work.

Live Picture image editing software is the central piece of this new mode of image production. Part of the beauty of the unique technology of Live Picture is the capacity for one scan and one editing job to be used for many purposes, at different resolutions, and with maximum image quality for each use. Other important features of Live Picture include the unprecedented speed with which one can work with large image files, the unfettered ability to selectively undo one's edits, and the fact that using Live Picture requires no large investment in memory chips or special hardware configurations. Without it, creating the images for this book in an affordable, elegant fashion would simply have been impossible. The practicality of digital imaging for professional photography has taken a quantum leap because of this new product.

Each of the RGB TIFF scans for this book exceeded 210 megabytes in size—the equivalent of about 70,000 pages of text. The final Live Picture IVUE image files that needed to be on-line totaled nearly twenty gigabytes, equivalent to over six million pages of text. Conventional prepress production would have used scans tailored to the exact size of the published image and required files only one tenth as large on average. In the conventional process, however, the files would have had little value for subsequent uses and I would have been deprived of tremendous creative control.

In order to realize Live Picture's promise of practical, high-resolution rendering of photographs with a computer, many other technologies were also utilized. Eastman Kodak's broad and deep involvement in a vast range of these technologies has

made this company the backbone of the project. Beginning with the Ektachrome films used for all the originals and ending with the plates used to print the book, Kodak's products, people, and support have made the realization of *Canyons of the Colorado* possible.

One such product is Kodak's Writable CD media, which serves three vital functions in the imaging process. First, digital imaging requires a reliable and inexpensive archiving method, and nothing compares with their Writable CDs for this purpose. Second, when using Live Picture it is practical to store the image file on a CD rather than on a hard drive for the entire editing process (after dust spotting and other pixel cloning are done), if you also store a JPEG-compressed version on the hard drive. This solves the problem of how to keep such a huge amount of data on-line. This can be done because with Live Picture the image file is never actually changed during editing; because viewing the file requires only small amounts of image data to be moved; and because the two versions of the image file can be interchanged, the file on the CD being used only for the final build. Thirdly, CDs are a superb medium for sharing large files, because CD-ROM drives are commonplace and writing to CDs is now simple, inexpensive, and reliable.

Two other vital parts of this imaging process are the artful science of color management, which Kodak invented, and accurate prepress proofing. For this book I chose to use Kodak's digital proofing systems to maximize the flexibility of the production process and to allow for a custom match to the printing press in Singapore. The new Kodak Digital Science Desktop Color Proofer 9000 made it possible for me to make two-page, four-color, dye diffusion thermal transfer proofs in my studio that simulated the press. The DCP 9000 is the fastest, most accurate, and most consistent "dye sub" proofer yet made. Unlike some other proofers, it does not require a dedicated computer for efficient throughput thanks to its very fast, embedded PostScript hardware RIP. The proofer utilizes a sophisticated color management system that allows the user to readily customize supplied target profiles for a precision match to a given press or other device. The open architecture of the proofer also allows it to be used with a wide range of other color management solutions. The DCP 9000 functions beautifully as a proofer for nearly all kinds of digital output and has become an indispensable part of my digital imaging work.

I also used Kodak's Approval digital proofer, which was carefully custom matched to the printing press for final proofs of great accuracy. The Approval creates proofs by using high-intensity lasers to expose color donors, which causes image dyes to be transfered to a dimensionally stable intermediary and subsequently to a paper receiver sheet; the resulting proof has an actual halftone dot structure similar to the final printed page. This eliminates the expensive separation negatives or positives used with traditional graphic arts proofing systems. Also, as the graphic arts industry increasingly utilizes direct exposure of printing plates from digital files, filmless proofing is becoming ever more necessary.

Live Picture supports the new standard for color management, Apple's ColorSync 2, which utilizes standardized color device profiles to, for example, make the image on a monitor look like the eventual output. X-Rite Incorporated's X-RiteColor family of hardware and software is the finest solution available for the colorimetric measurement needs of digital imaging professionals. The Monitor Optimizer and DTP51 Auto Scan Colorimeter were used to calibrate and profile my monitor and the press, which made editing and proofing even faster and easier.

The photographs in this book were made entirely with 4×5-inch Ektachrome 6117 and 6121 films, which make it possible to beautifully capture a broad range of subject matter. Kodak's Q-Lab program has for many years guaranteed tightly controlled processing of my originals at my custom lab in San Francisco. Kodak's graphic arts films, plates, and chemistry have all been used in the creation of this book. Many other Kodak products and services have been instrumental in my career and have contributed to my readiness to do this work.

By combining the resolution-independent character of Live Picture's image editing capabilities, its unique ability to manipulate huge images without a time penalty, its relatively modest hardware requirements, and its ability to selectively undo nearly any portion of one's image editing work at any time, with the expertise and products of Kodak's color management group, the greater economy of using only one image file for every purpose can finally be realized. This capability allows me to offer digitally produced, high-quality photographic prints in a variety of sizes made directly from this book's high-resolution master image files.

This new way of producing images using digital technology overcomes many of the limitations inherent in photographic processes and makes photography a better complement to human visual perception. As I edit images I can now combine some of the best features of painting with those of photography and make wonderful pictures out of images that otherwise would simply not have worked. Color photography is finally coming of age.

—Joseph Holmes

# ACKNOWLEDGMENTS

There have been many contributors to the making of this technologically pioneering book, without whom it would have been impossible.

"From image capture to the printed page," Eastman Kodak has facilitated the project in a great many ways that involve both traditional and digital imaging products. Many people at Kodak have been extremely helpful and deserve special thanks: John Altberg, Rick Allen, Marianne Samenko, Myron Kassaraba, Dick Lorbach, Tim Elliott, Carl Gustin, Cliff Wilson, Hapet Berberian, Mike Shea, Barbara Jessup, Chris Heinz, Bill Moore, Mike Proulx, and many others. Kodak's financial and technological support were crucial to the book's realization.

Live Picture, Inc., of Soquel, California, has been instrumental in making the book happen, in part through the creation of the most central technology—their fabulous image editing software, Live Picture—and in part through the help and support of Robert Blumberg, Mark Sangster, Philippe Bossut, John Sculley, and Eric Santarelli. My work as photographic consultant to Live Picture, Inc., has directly and indirectly benefited this project, as I worked with them to devise the ideal set of color correction tools for Live Picture 3.0.

X-Rite, Incorporated, of Grandville, Michigan, provided the X-RiteColor family of products I used. These instruments provide the finest measurement capabilities available for profiling monitors and output devices. Accurate simulation of the output on one's monitor is vital to the efficiency of expressive image rendering with a computer. Special thanks to Iain Pike for his assistance.

Tulip Graphics in Berkeley, California, did the extraordinary, high-resolution RGB scans necessary for this project. Thanks to Rich Capone and Bruce Anderson for a beautiful job.

My producer, Catherine Kouts, has untiringly attended to countless difficult details of production, with a passion for the project that matches my own. John Hubbard and Ed Marquand at Marquand Books in Seattle created the book's beautiful design and Pamela Zytnicki polished the text. Annie Barrows and Karen Silver at Chronicle Books have provided invaluable assistance. The insights, encouragement, and assistance of my friend Henry Wilhelm, of Wilhelm Imaging Research, Inc., in Grinnell, Iowa, have been indispensable in making this book a reality.

Lee Sian Tee and Rick Marment of CS Graphics have my gratitude for their commitment to quality and for their enthusiastic cooperation in implementing the new methods of book production that this project required.

In addition to the production process, many people have contributed to my accomplishment of this body of work done over the last twenty years. Dave Brower deserves special thanks for his inspiration and appreciation of my work over the same period of time, as well as for the foreword he provided. For many of the opportunities I have had to experience and photograph the canyons of the Colorado I am indebted to Tom Pillsbury and to Steve and Janet Andersen. For the time and opportunity to create this work and share in its production I am most indebted to my wife, Page, and my daughters, Jessica and Courtney.

*Canyons of the Colorado* was produced and edited by Compass Rose Productions, Oakland, California, under the direction of Catherine Kouts.

Exquisite limited edition photographic prints of Joseph Holmes's images are available. He may be reached at (510) 526-4145 or via the Internet at either alpenglow@aol.com or jh@josephholmes.com. Please visit Mr. Holmes's Web site at josephholmes.com.

Text composed in ITC Legacy Sans with heads in Charlemagne and ITC Legacy Serif
Designed by John Hubbard
Copyedited by Pamela A. Zytnicki
Produced by Marquand Books, Inc., Seattle
Printed and bound by CS Graphics, Pte. Ltd., Singapore